# Iraqi Brush

Paintings by Fatimah Al-Asadi

Copyright © 2016 Fatimah Al-Asadi

All rights reserved.

ISBN-10: 1532950012
ISBN-13: 978-1532950018

# FATIMAH AL-ASADI

| | |
|---|---|
| Fatimah Al-Asadi | فاطمة الأسدي |
| Master's Degree in Linguistics | ماجستير لغة انكليزية / جامعة بغداد |
| PhD in curriculum design / university of Wyoming - USA | دكتوراه في تصميم مناهج اللغة الانكليزية / جامعة وايومنغ – الولايات المتحدة الامريكية |
| Exhibitions | المعارض |
| Annual Exhibit of the University of Baghdad, 2010 | المعرض السنوي لجامعة بغداد 2010 |
| Annual Exhibit of the College of Education – Ibn Rushd, 2010 | المعرض السنوي لكلية التربية / ابن رشد 2010 |
| Art Exhibit at the US Embassy in Baghdad, 2012 | معرض الرسم في سفارة الولايات المتحدة في بغداد 2012 |
| Arts and Stamps Exhibit at the US Embassy in Baghdad, 2013 | معرض الفن والطوابع في سفارة الولايات المتحدة في بغداد 2013 |
| Zainab: Arabic Media Exhibit, 2015 | زينب: سيدة الاعلام العربي، بغداد 2015 |

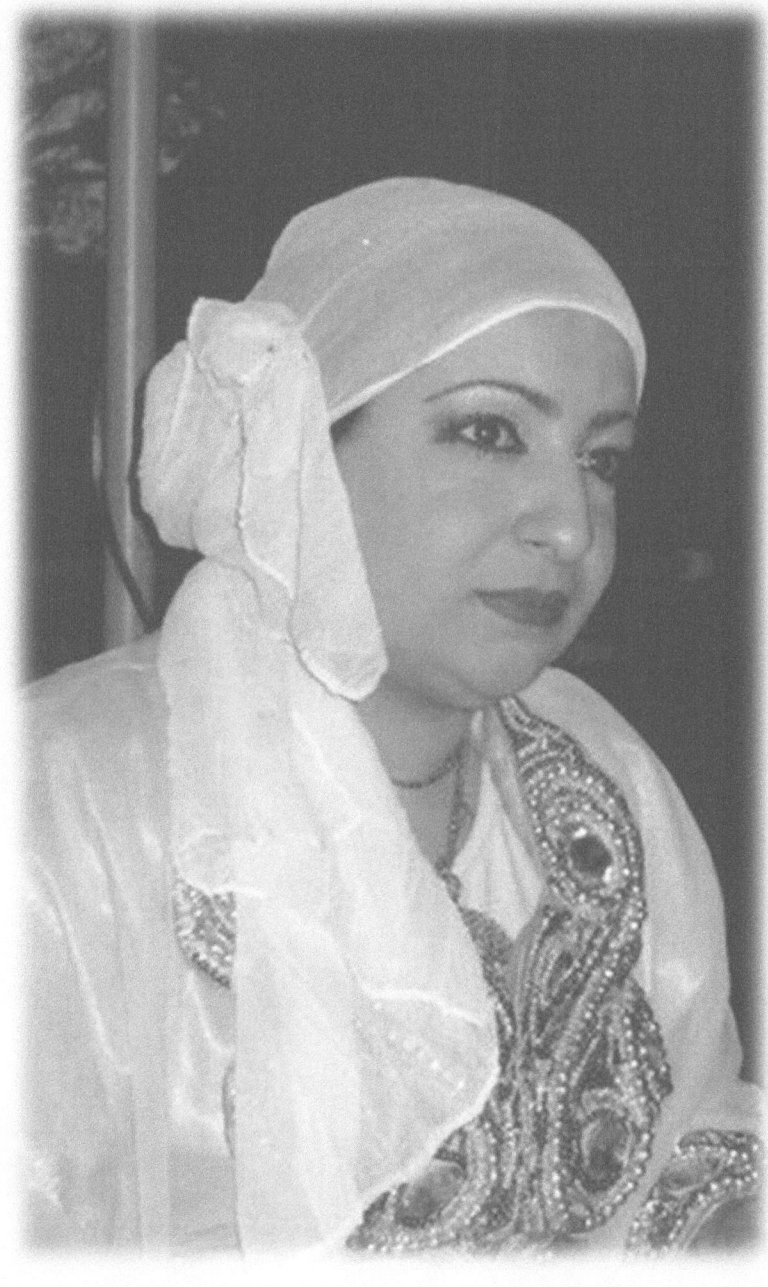

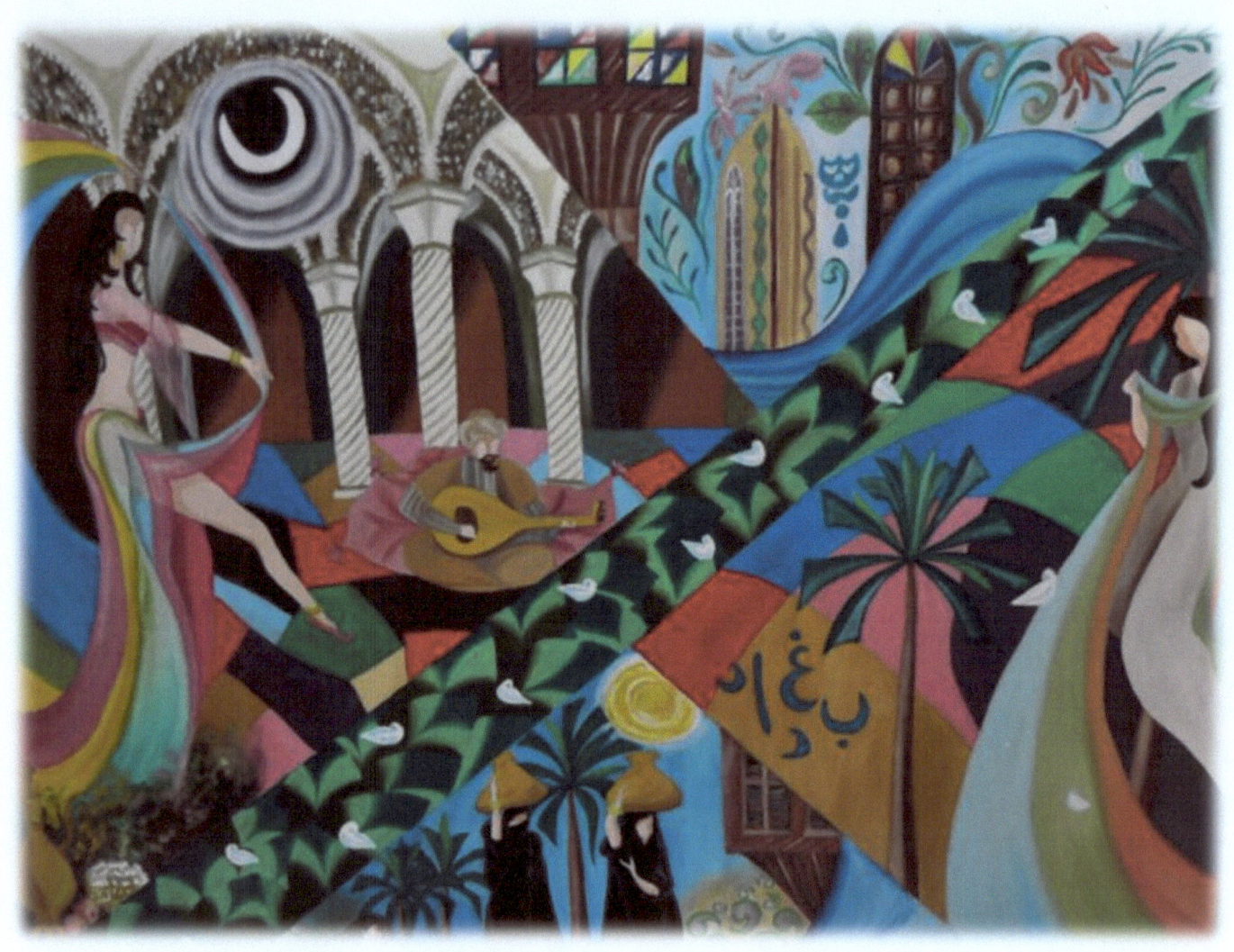

BAGHDADIAT

## ADAM & EVE

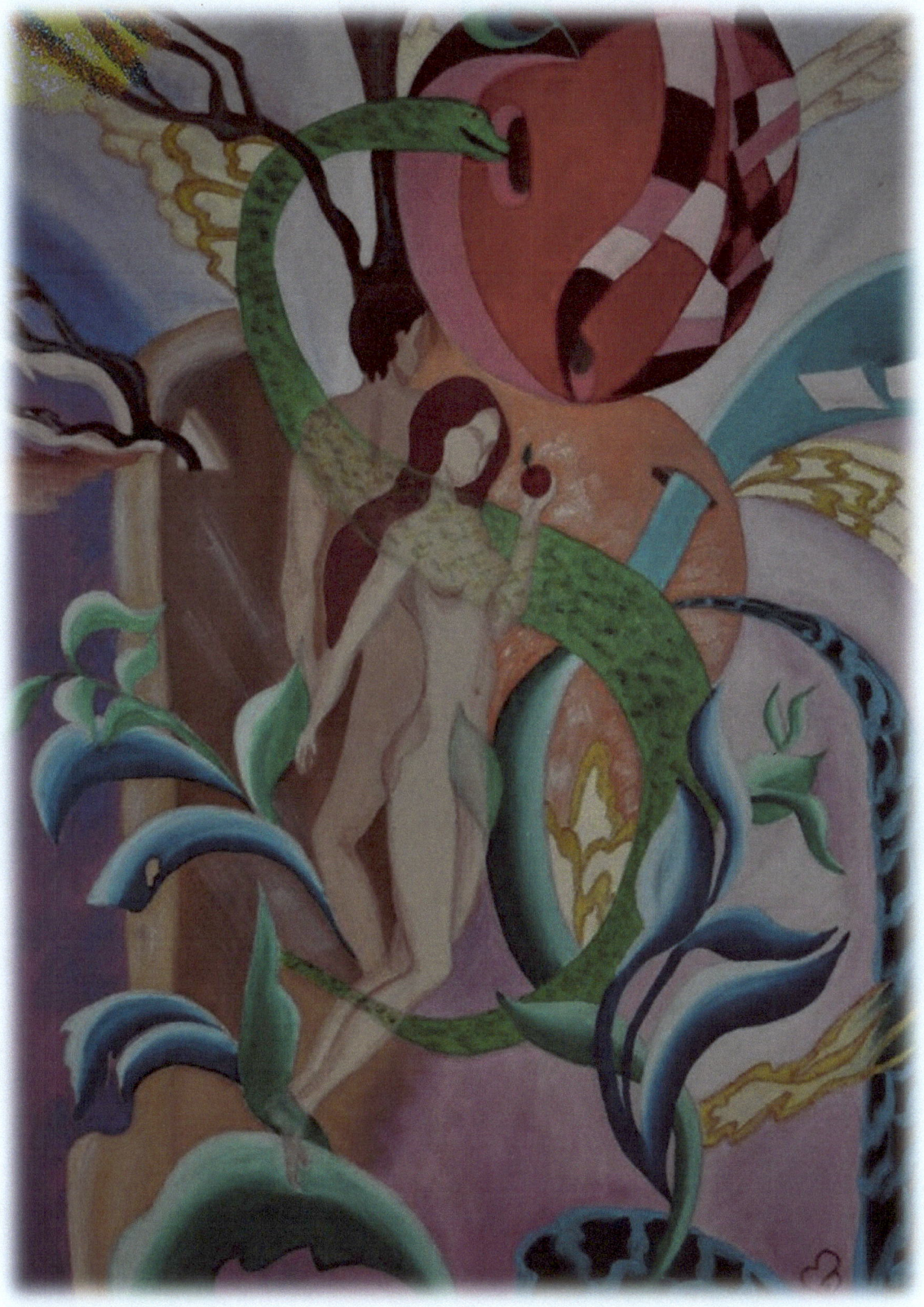

CRIMSON BENDING

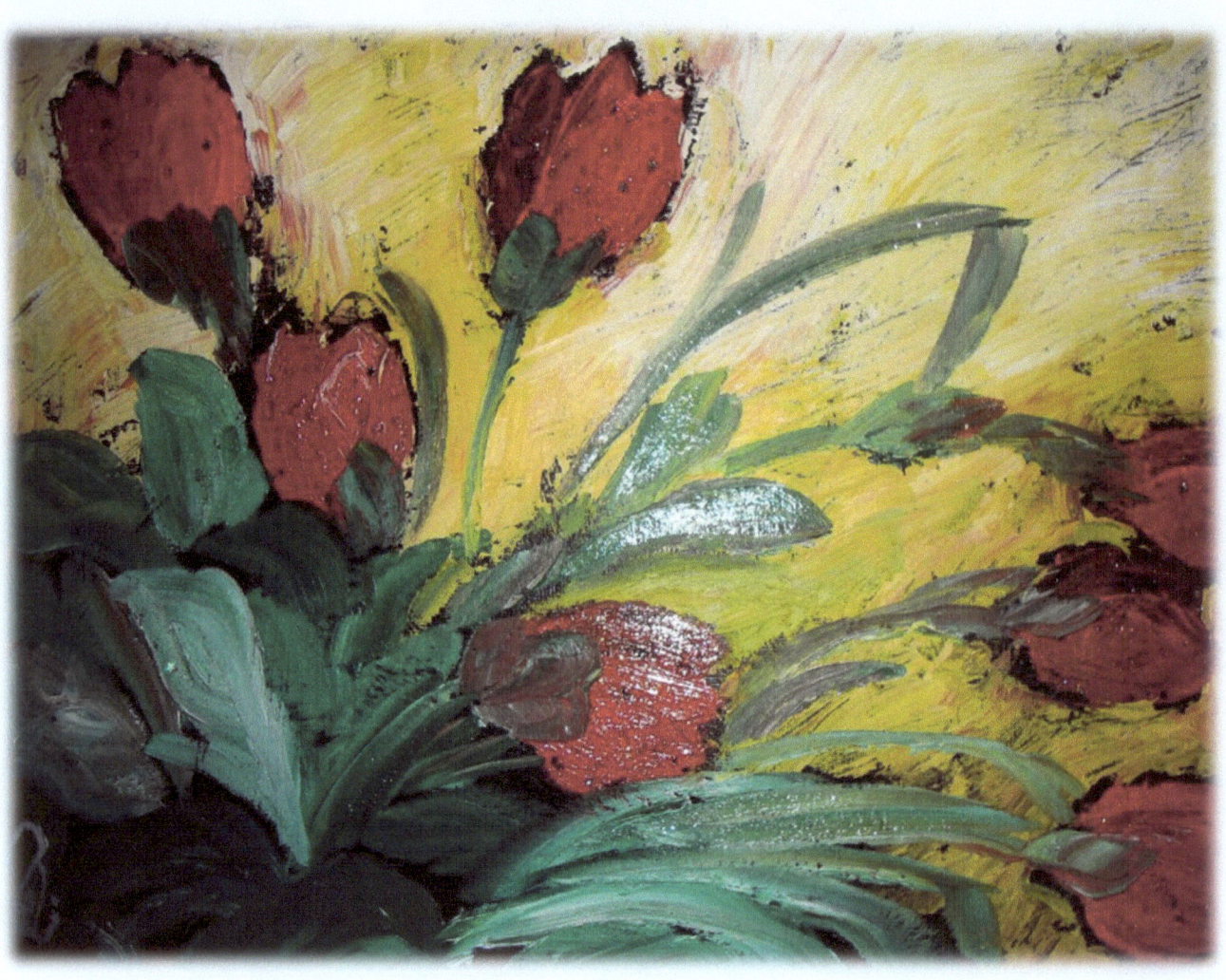

## LANTERNS

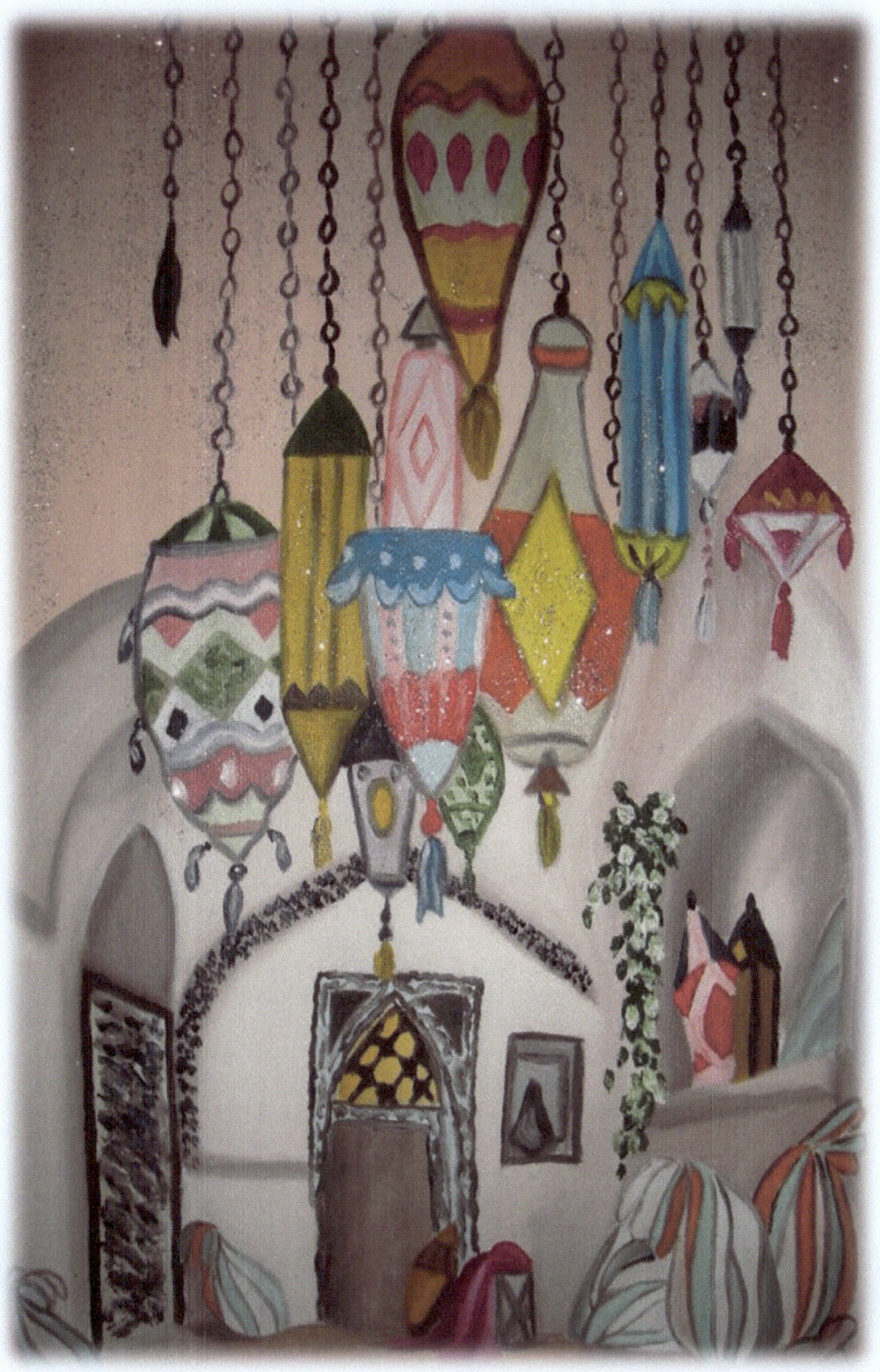

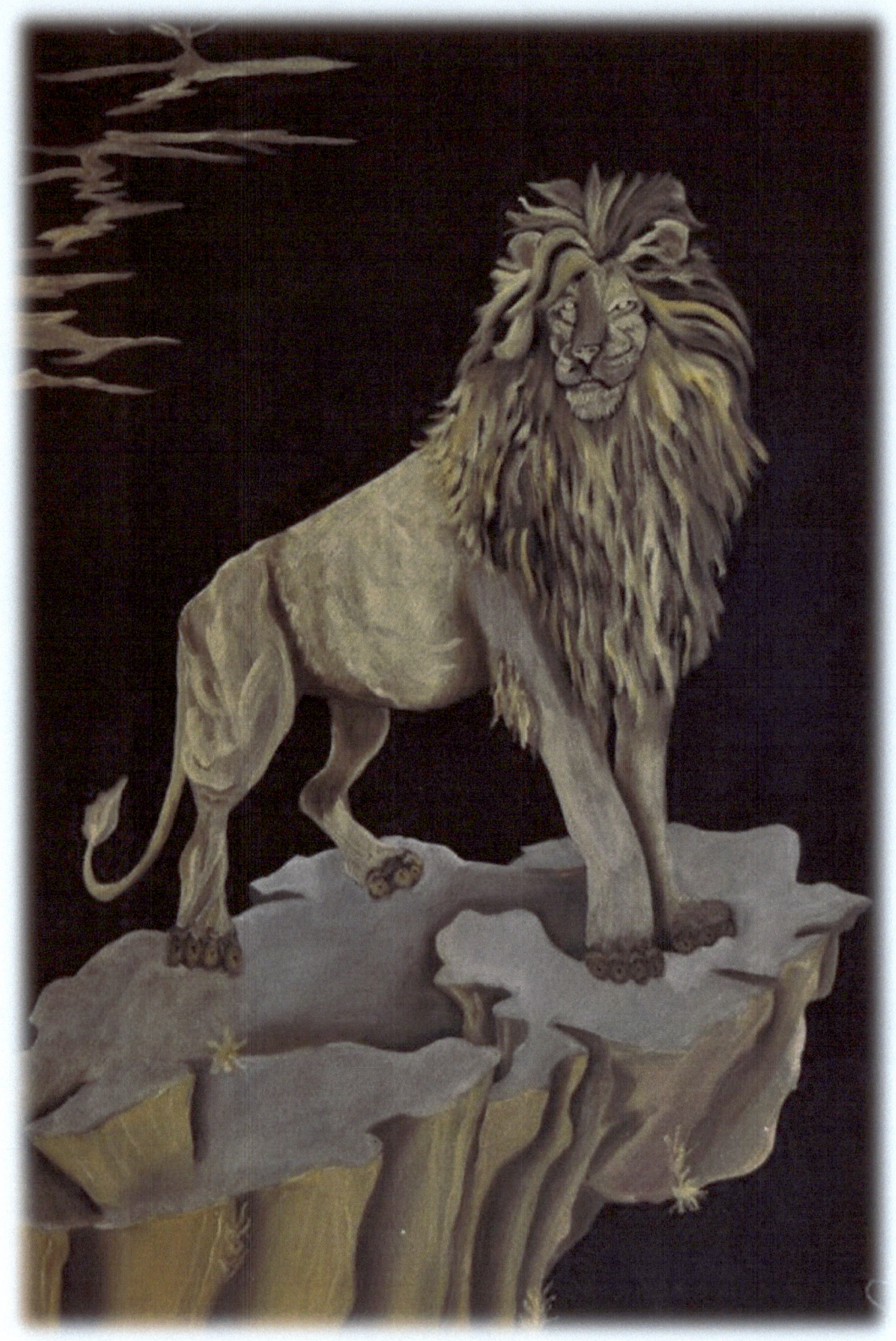

GLORY

## SUNSET IN AFRICA

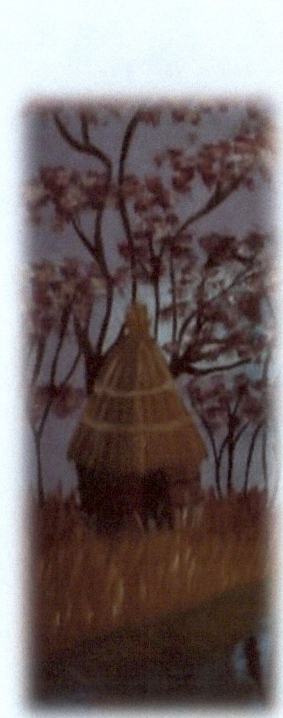
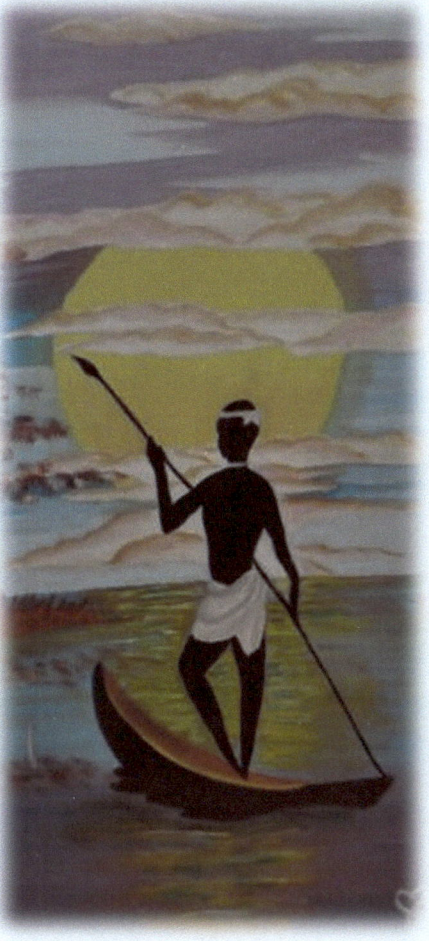

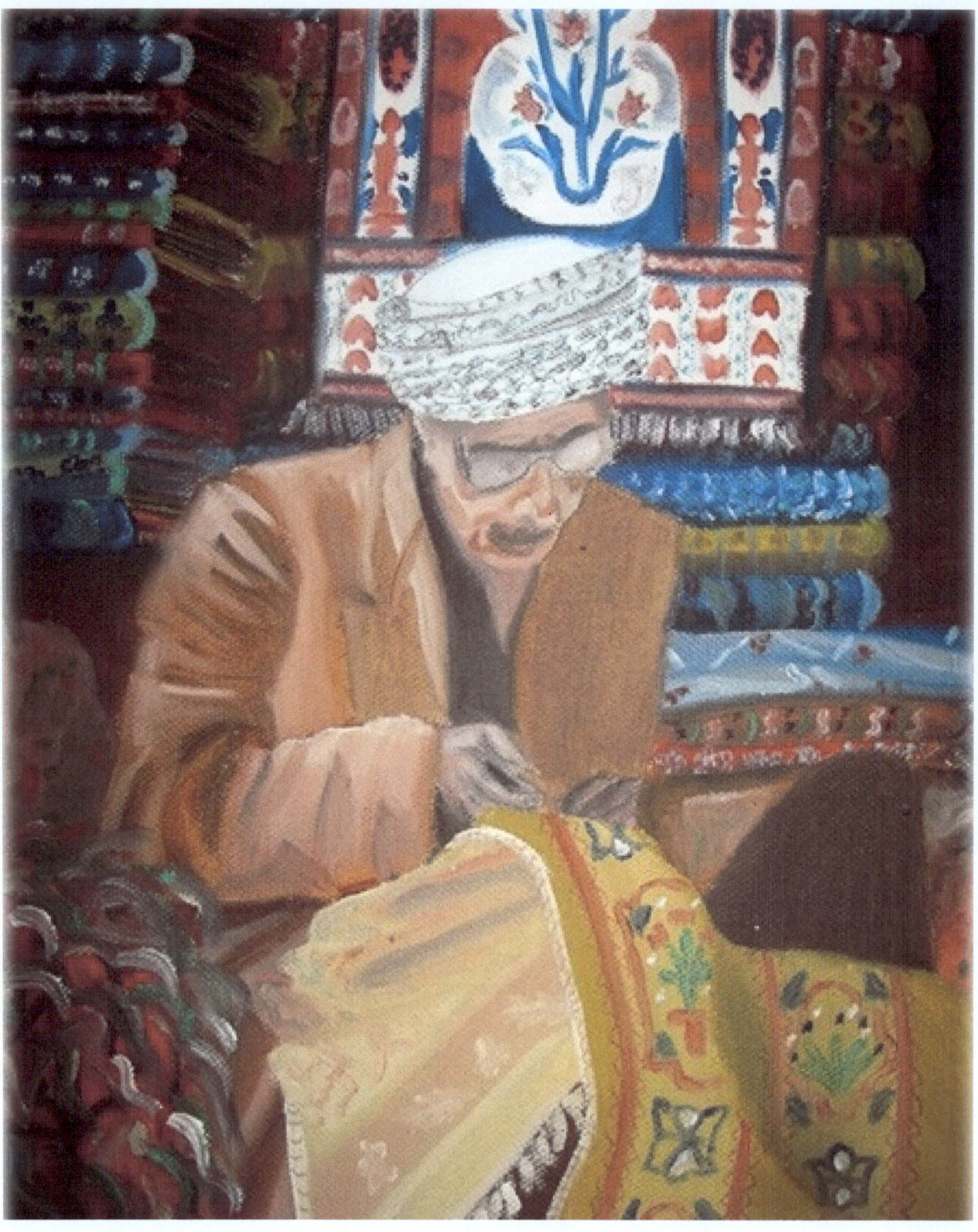

OLD CRAFT

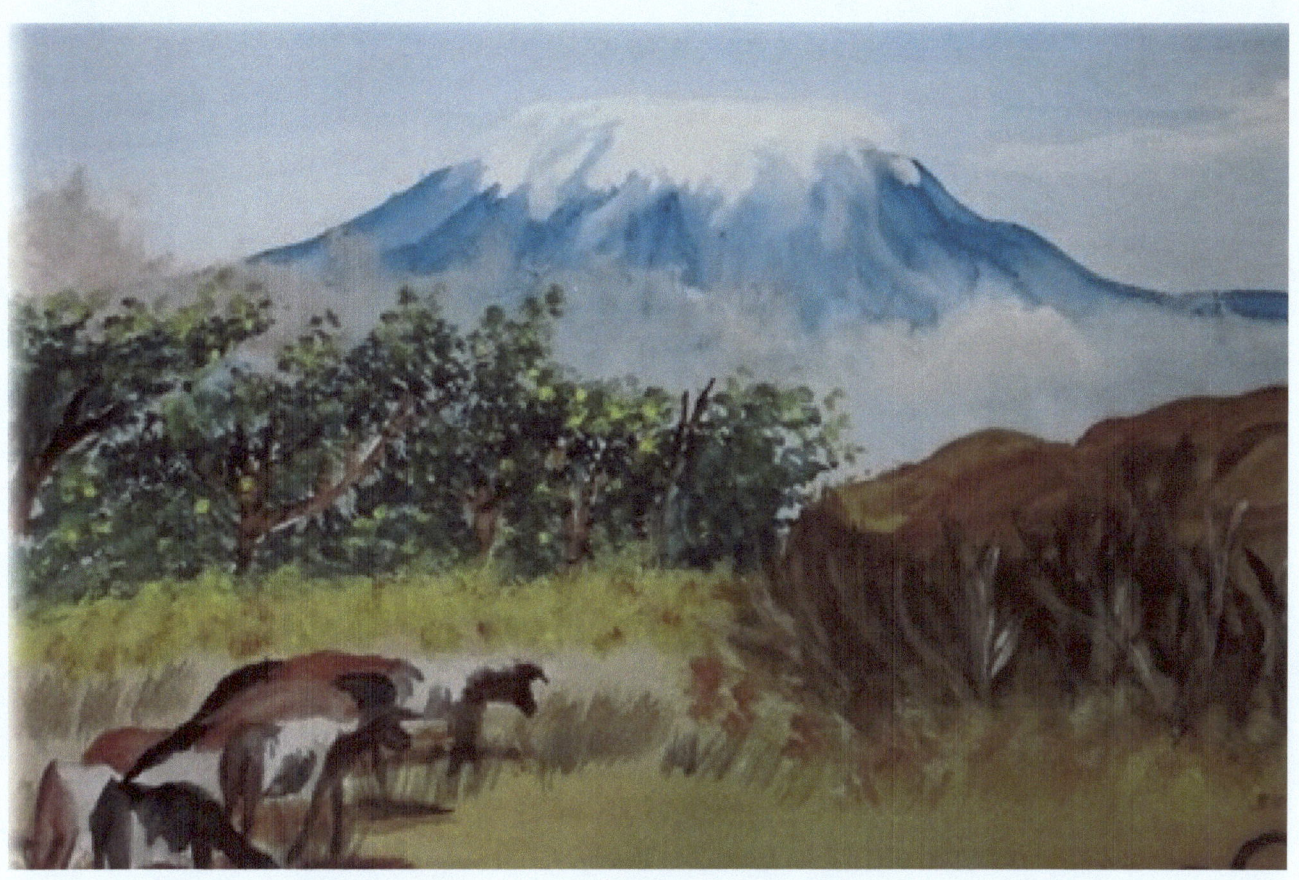

QUIET NATURE

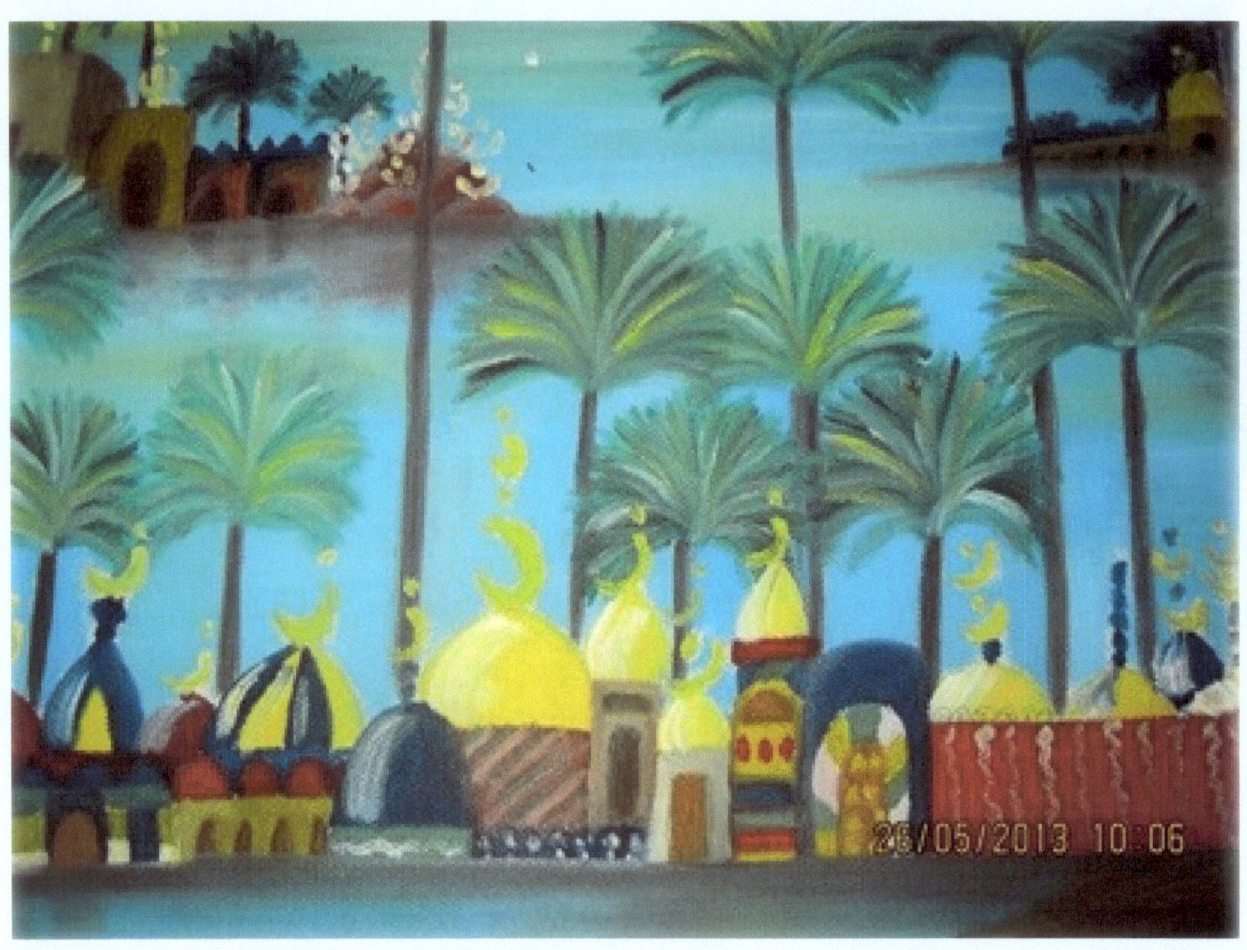

FOLKLORE

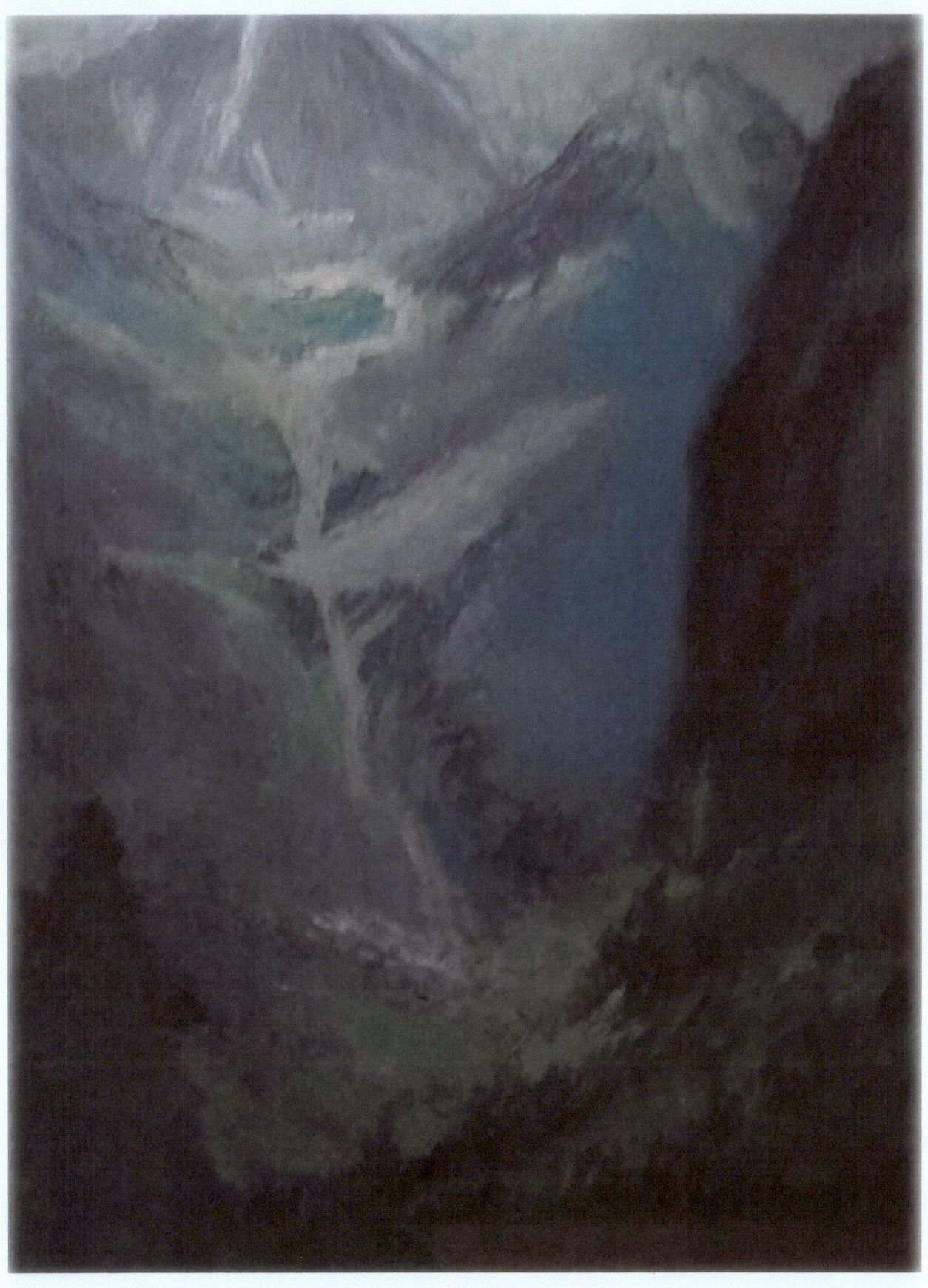

MOUNTAINS

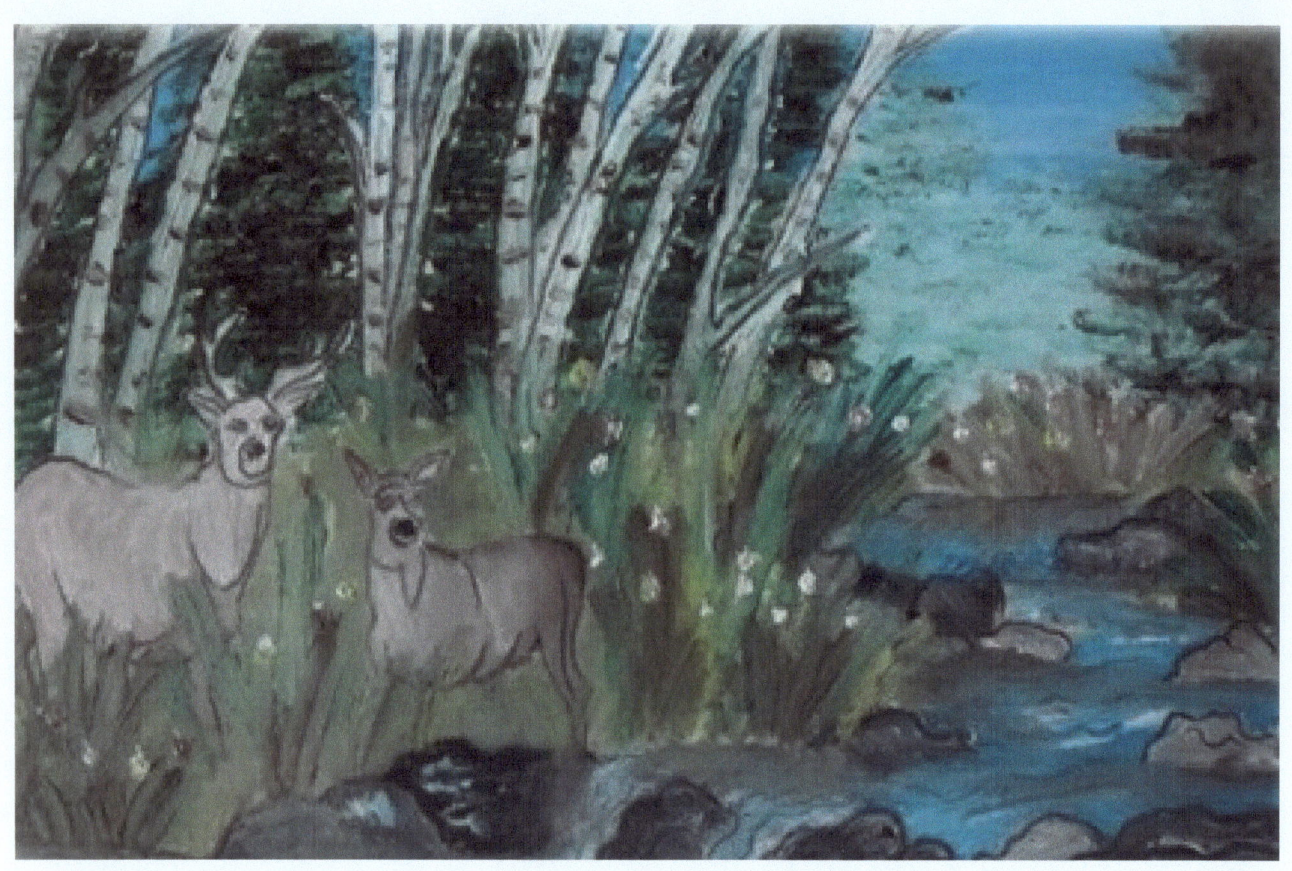

LISTENING TO NATURE

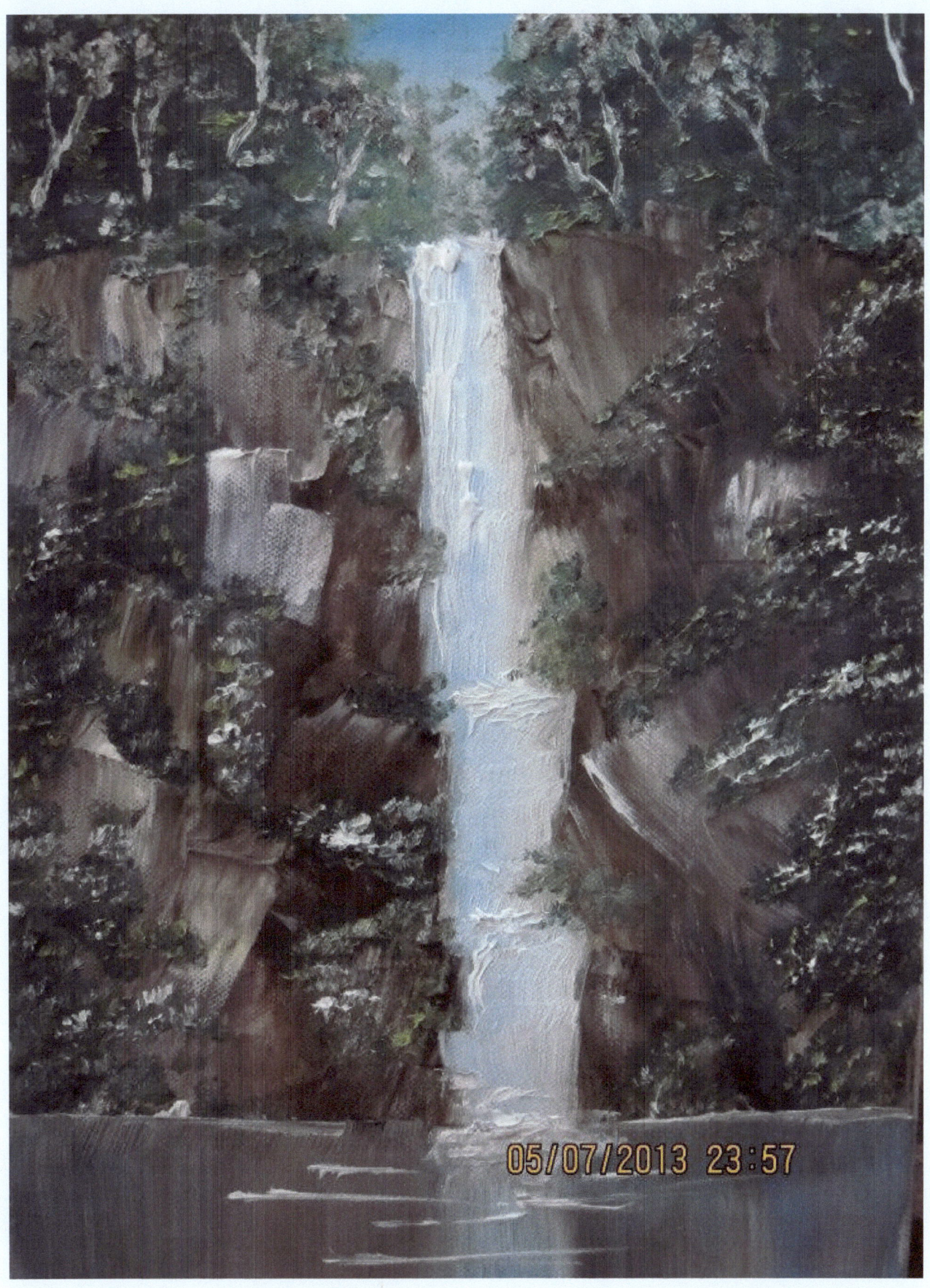

WATERFALL

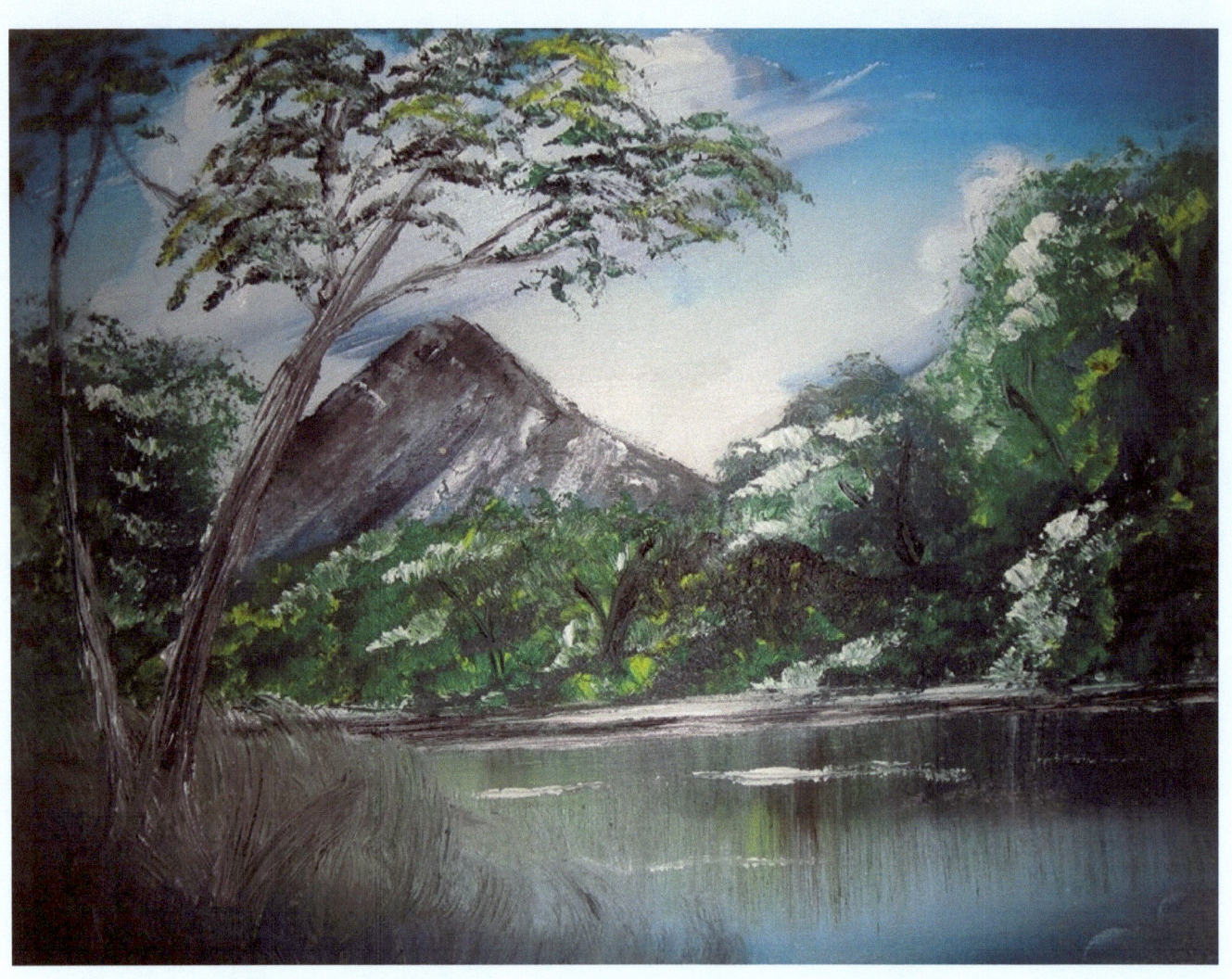

A LAKE

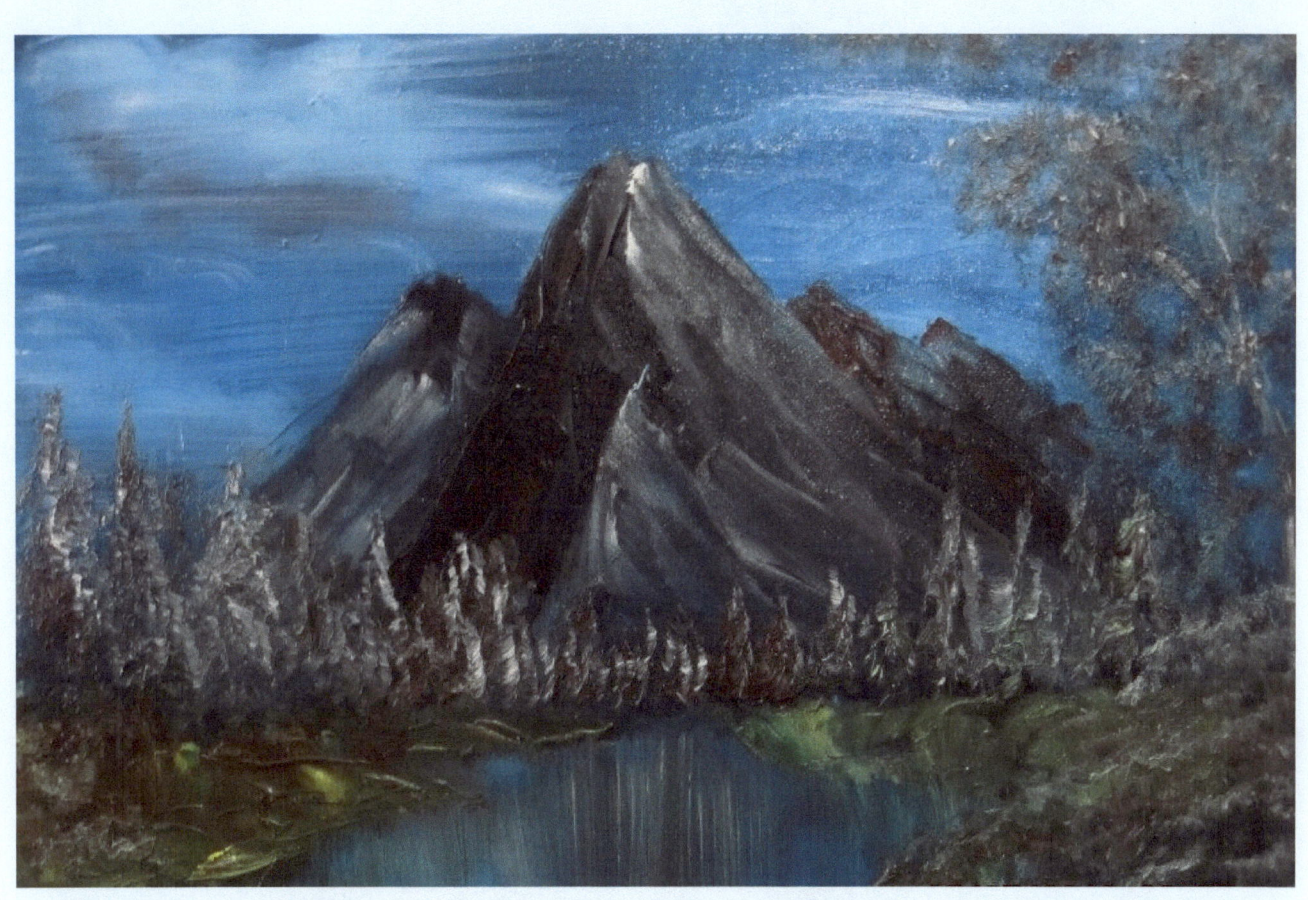

AT THE FOOT OF THE MOUNTAIN

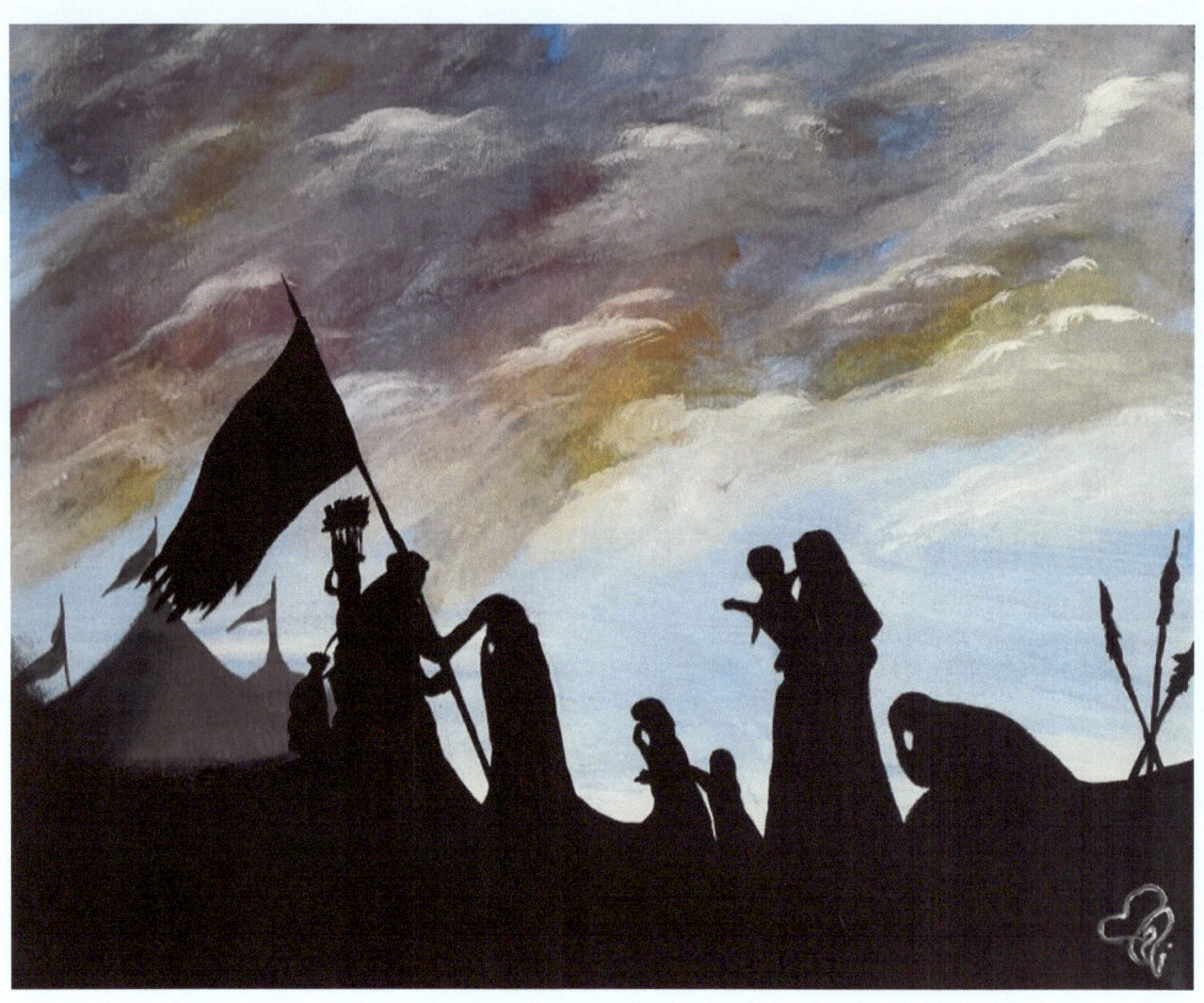

ZAINAB: THE MOUNTAIN OF PAITIENCE

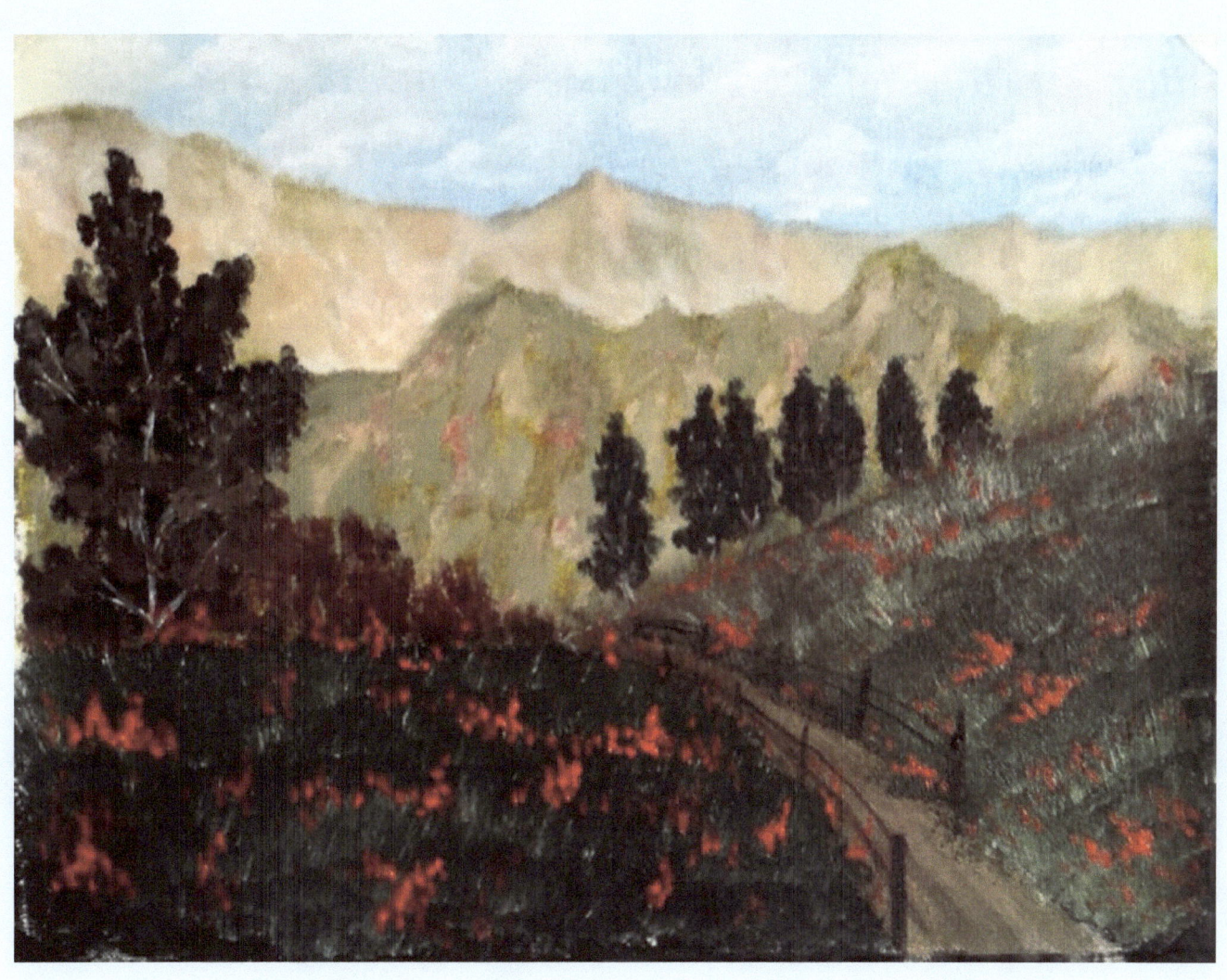

FARMS

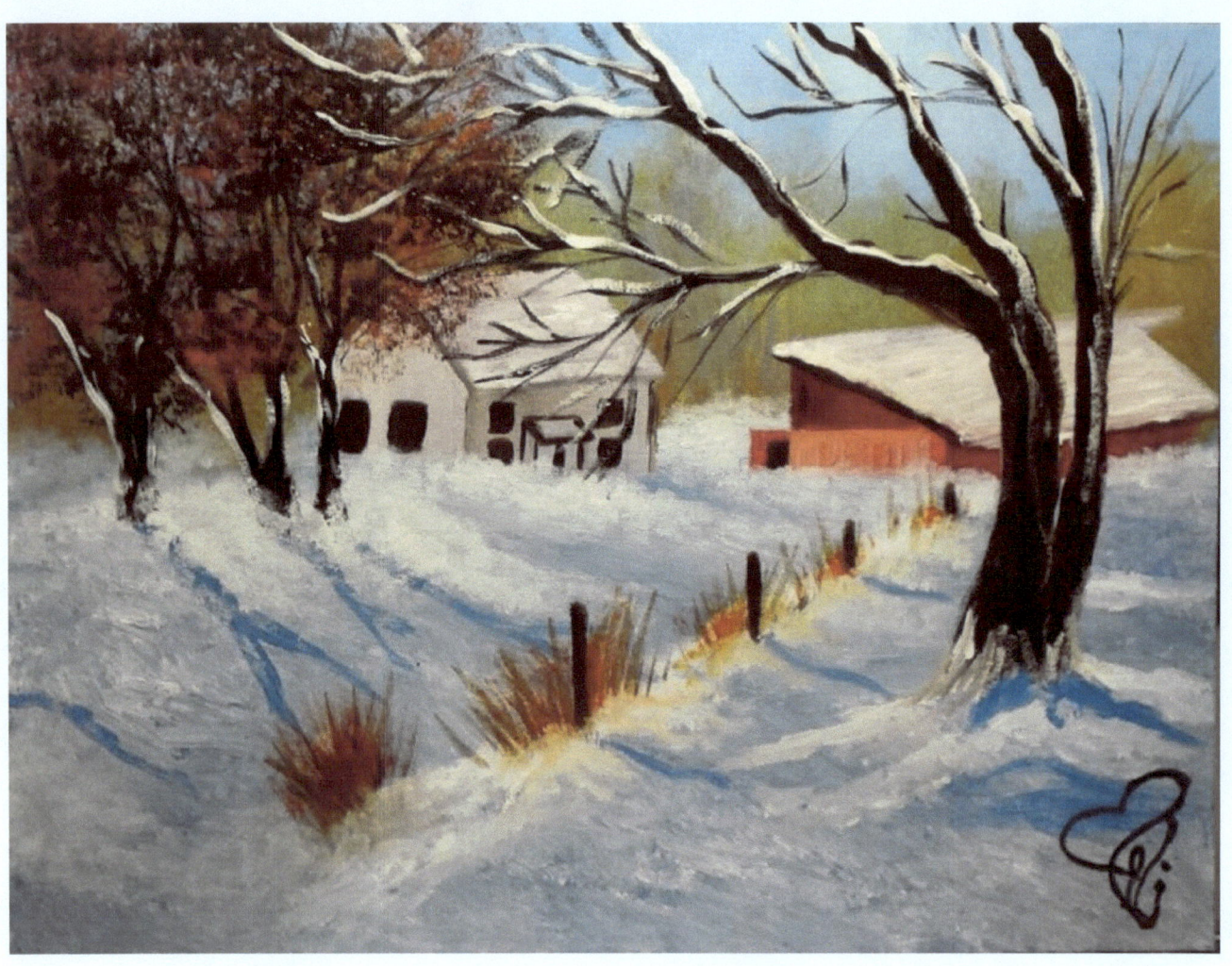

BARN

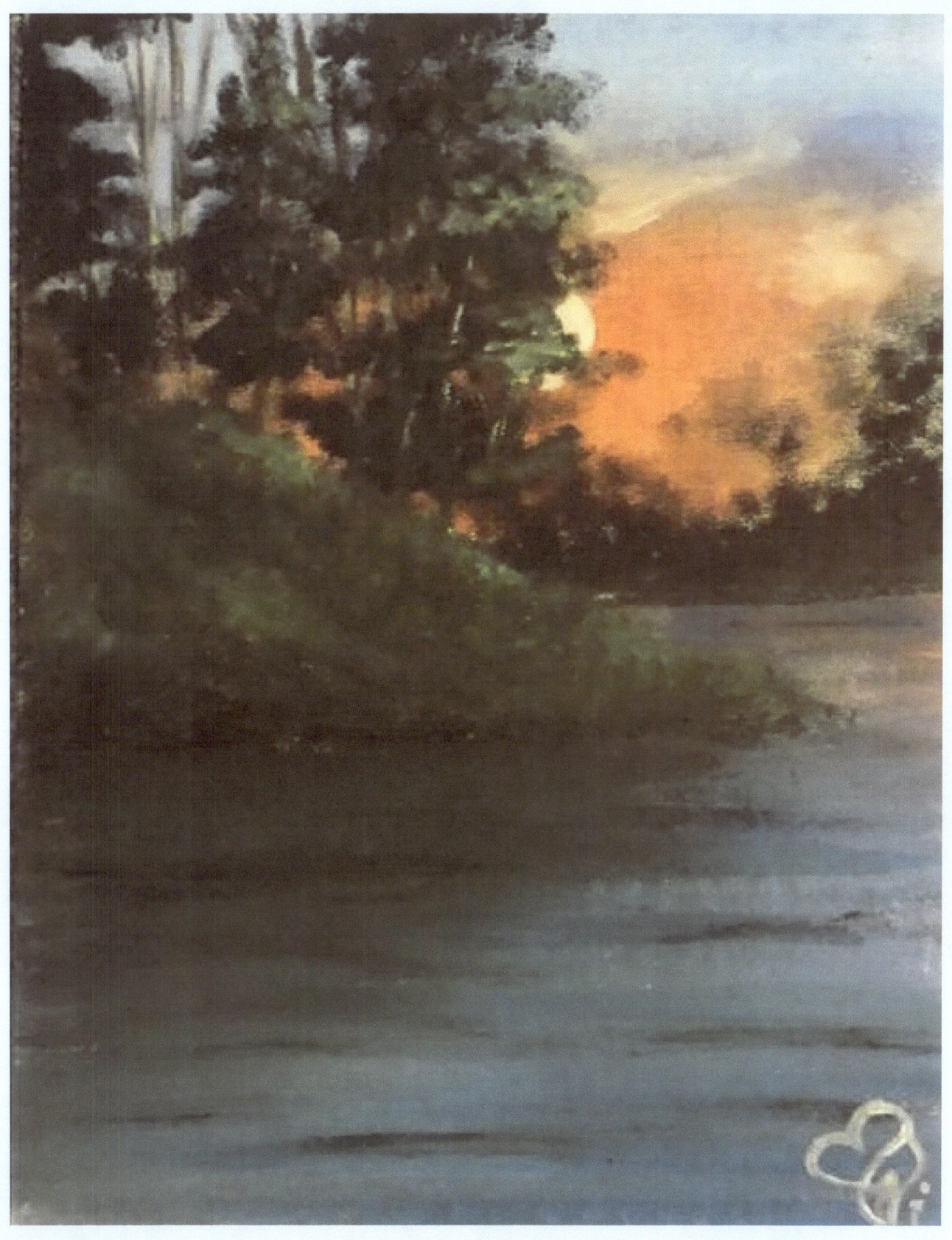

A SHY MOON

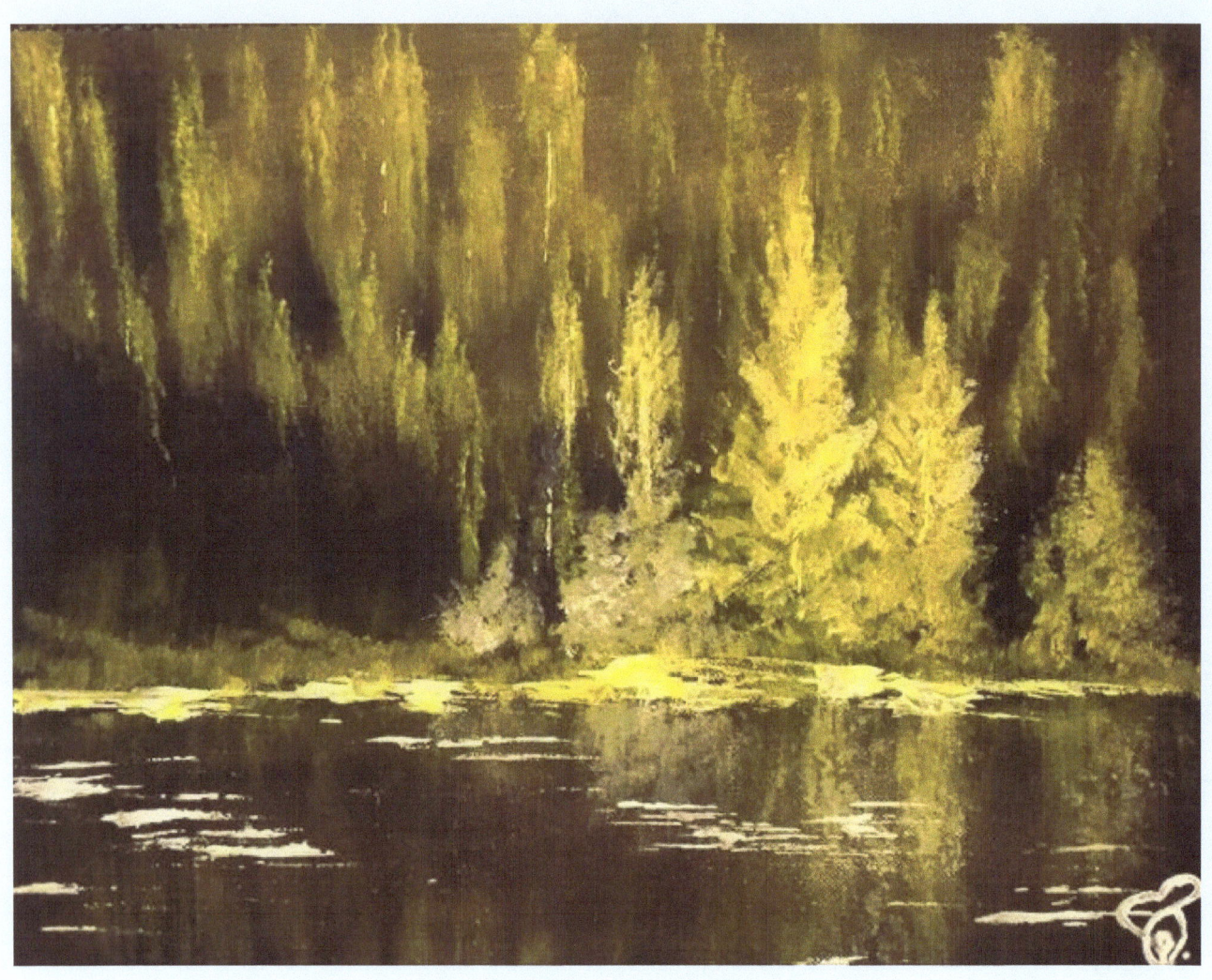

THE DARK WOOD

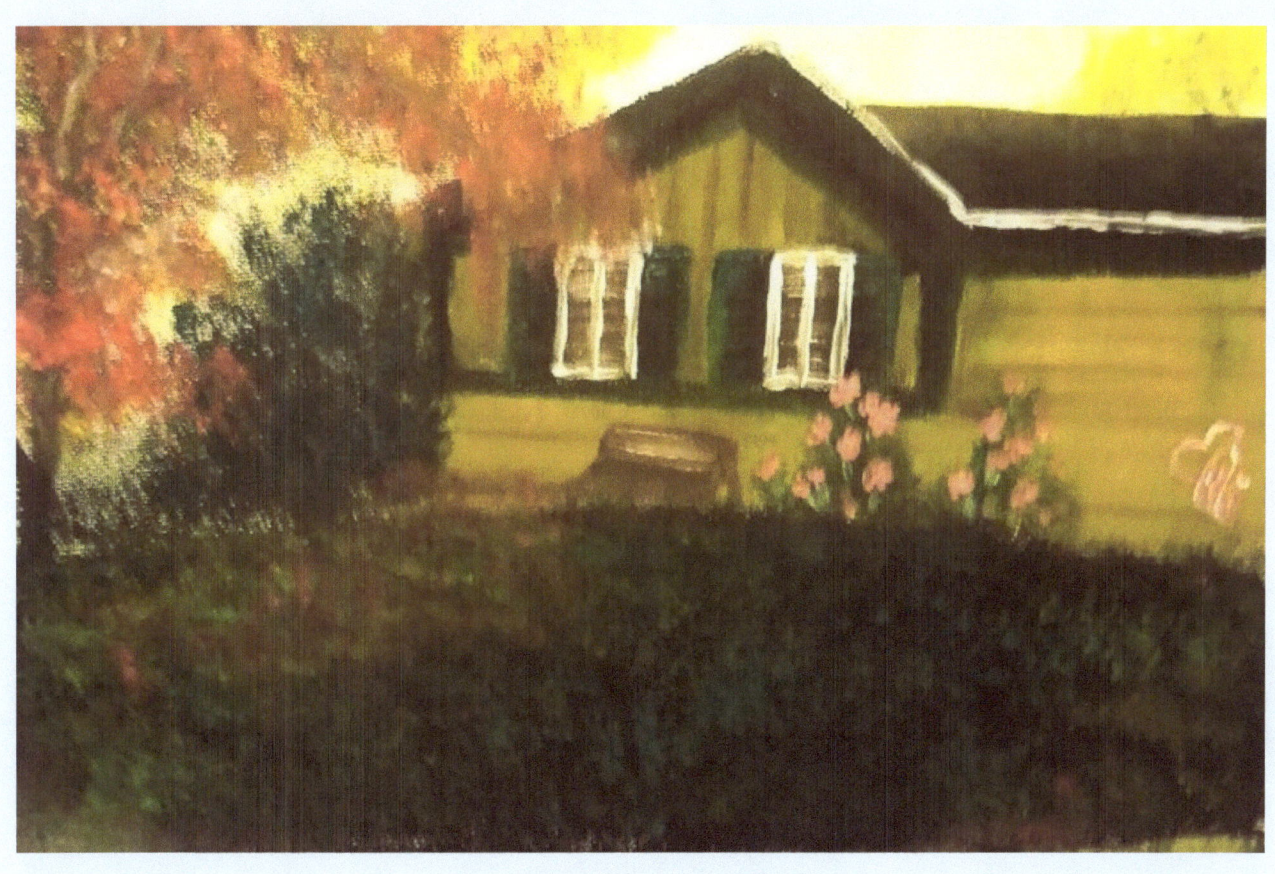

A HOUSE IN SPRING

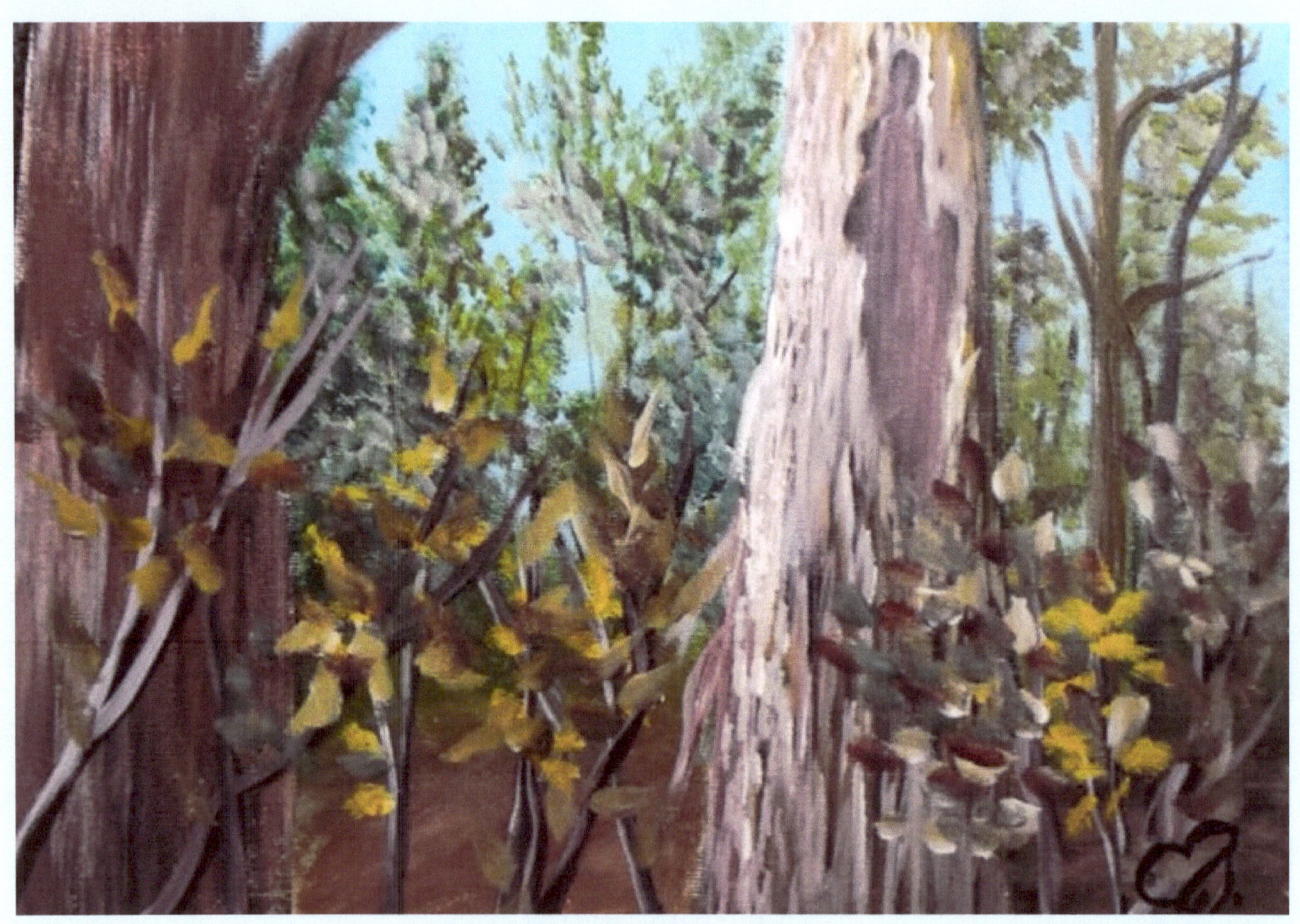

OLD TRUNKS

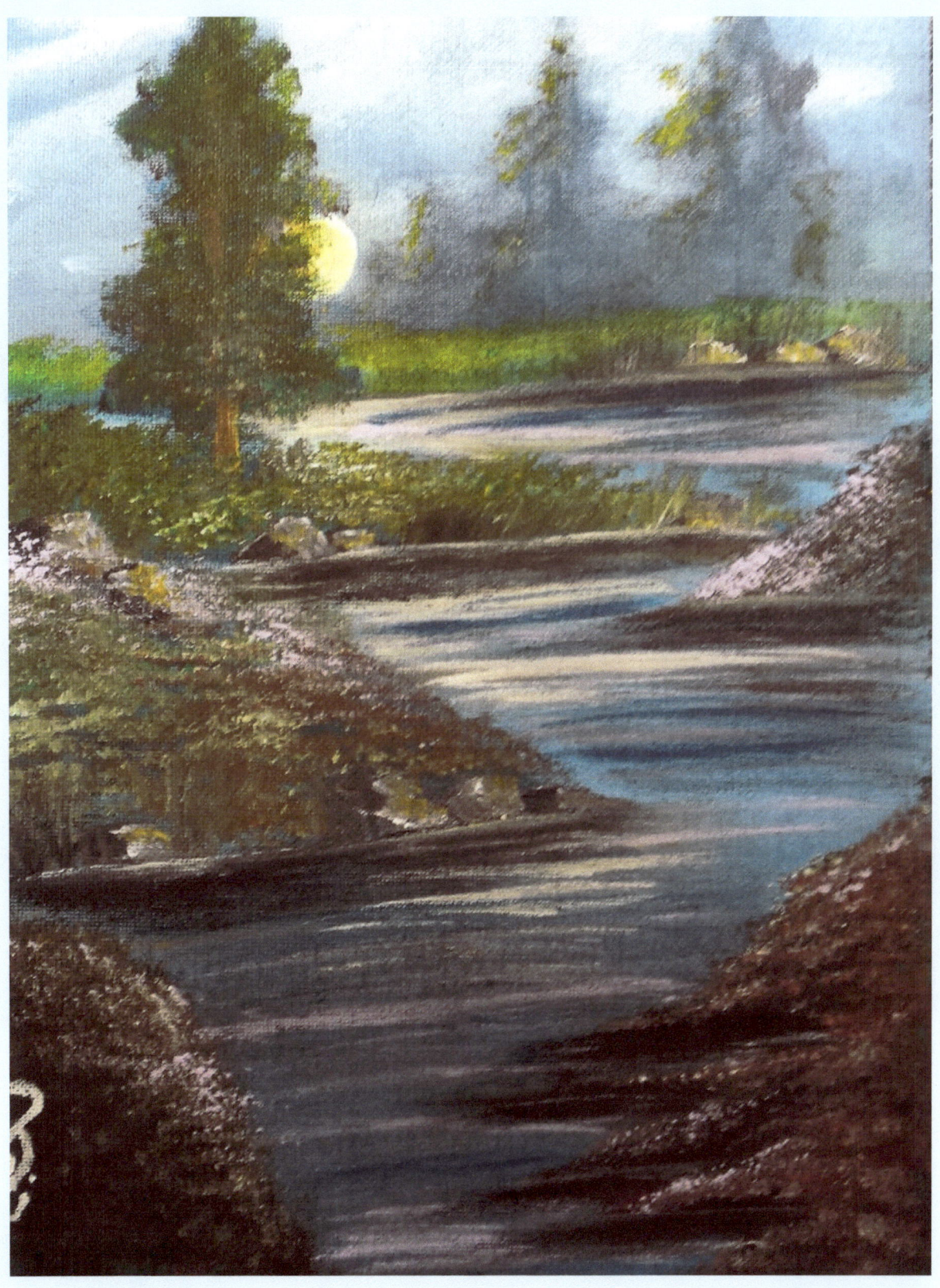

MOON LIGHT

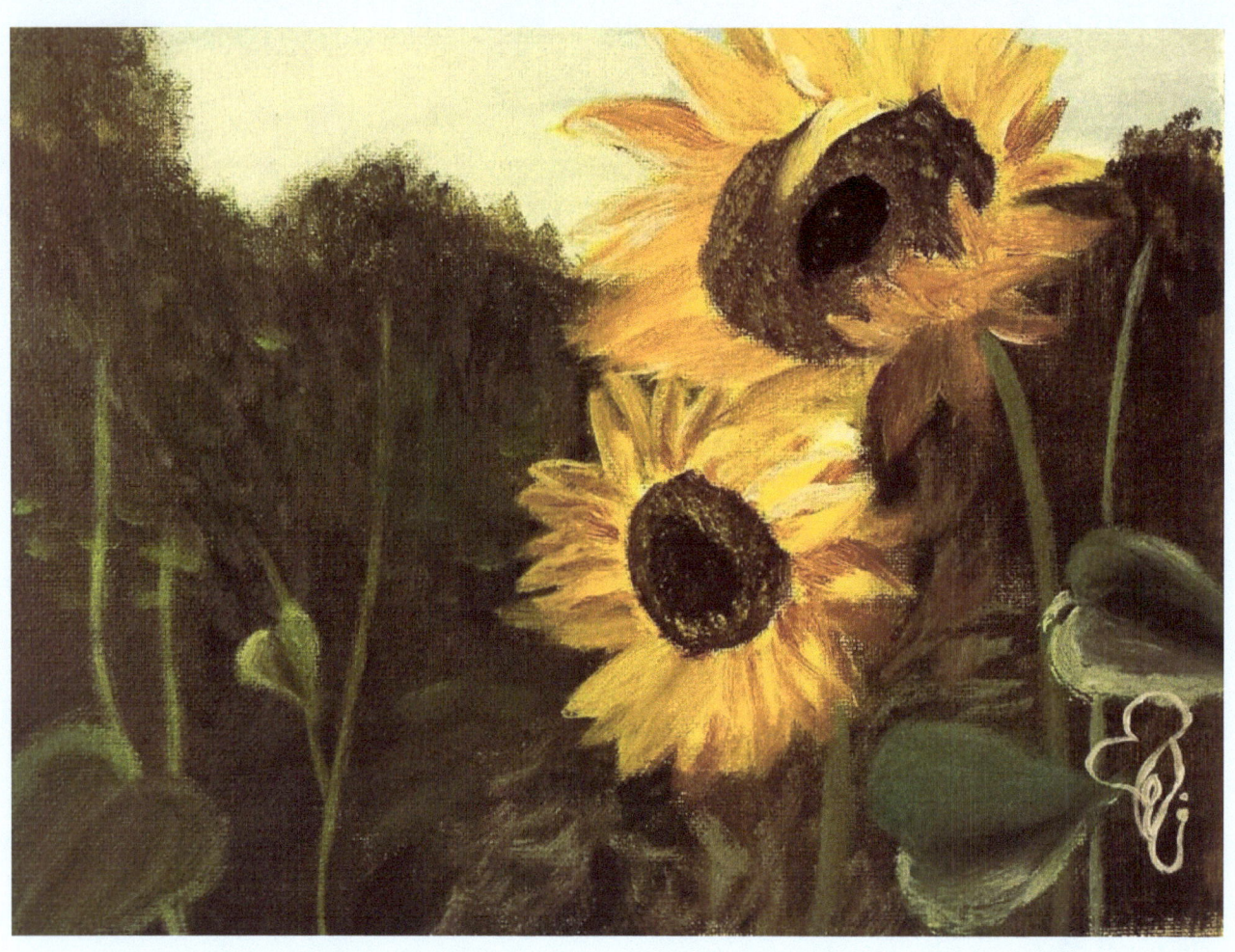

SUNFLOWERS

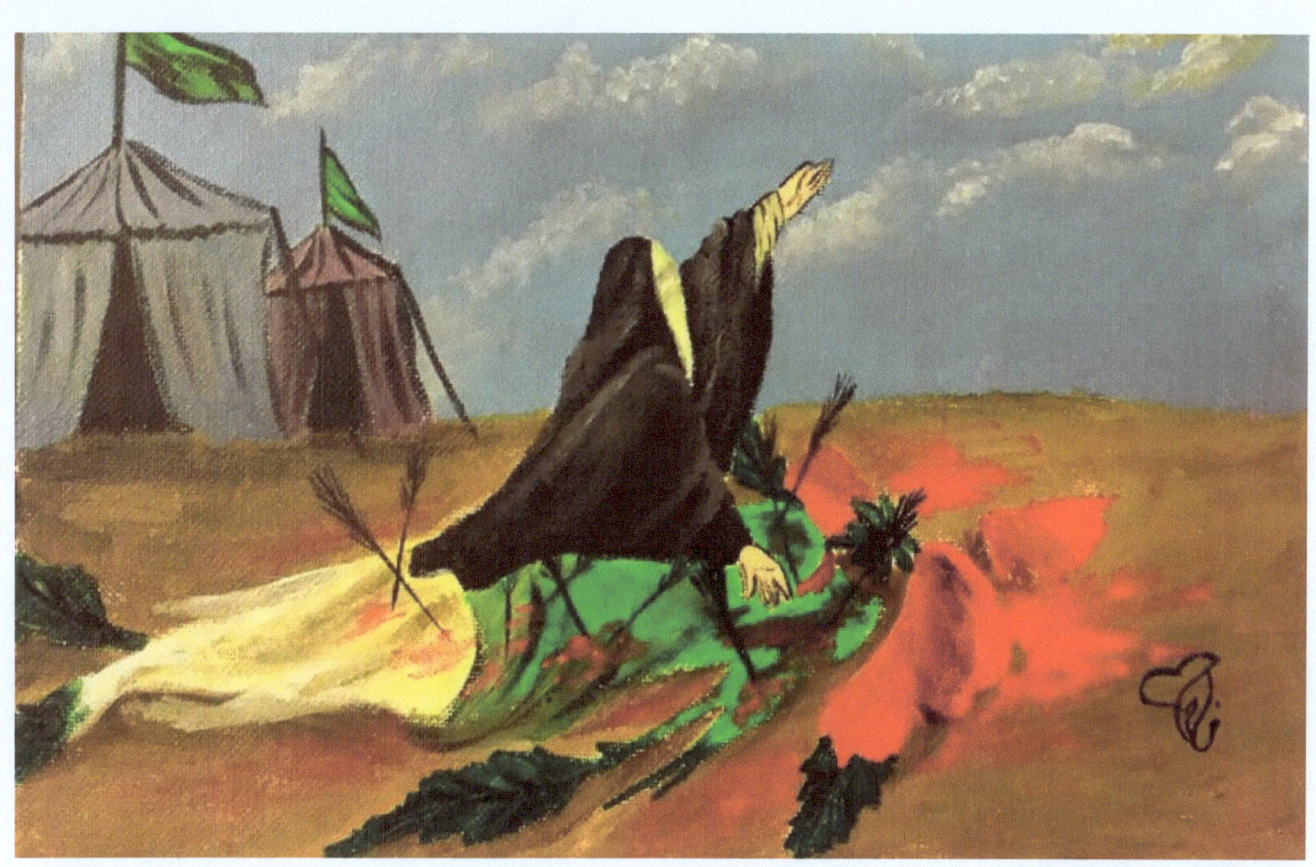

THE SLAYED ROSE

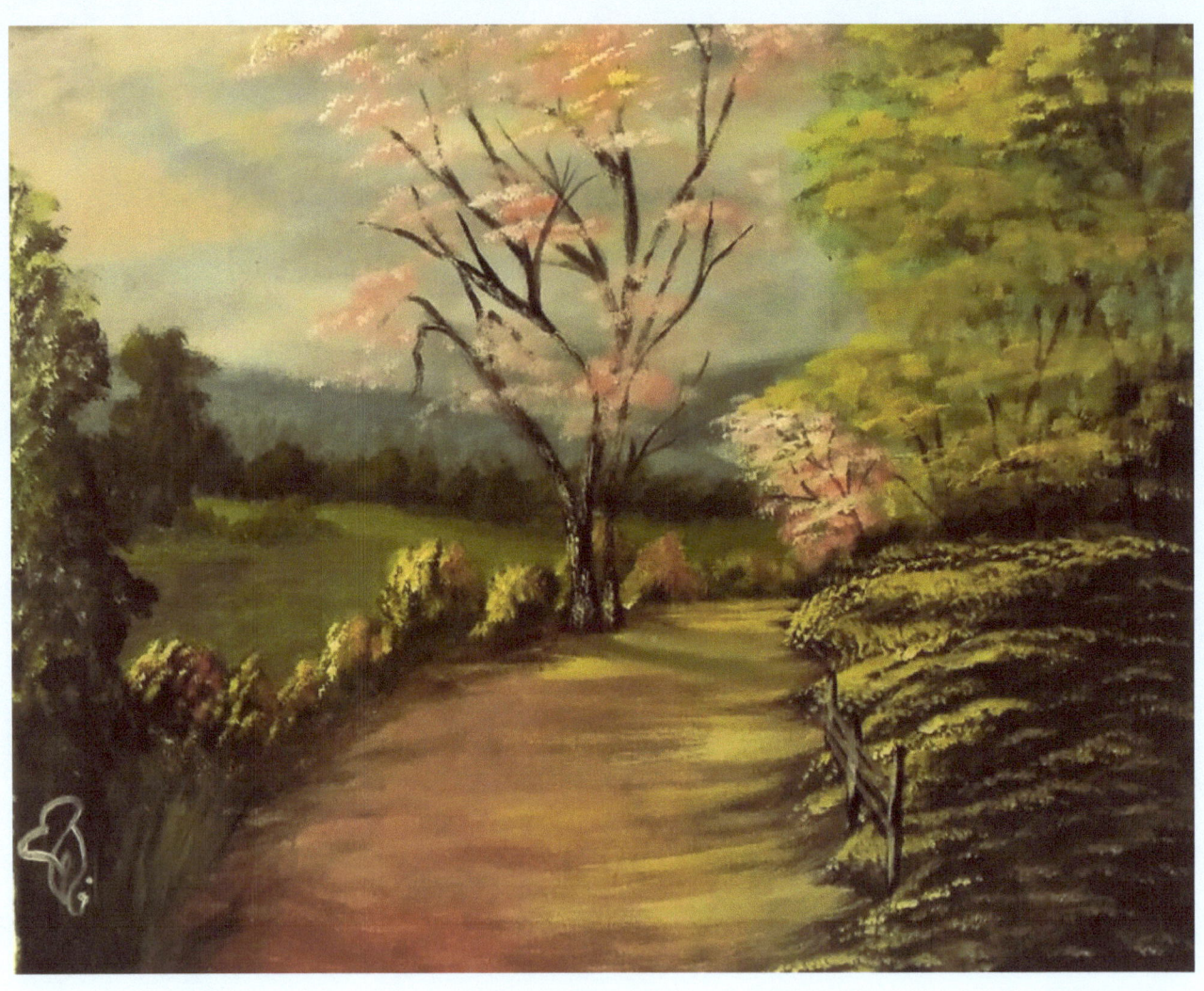

PINKY SPRING

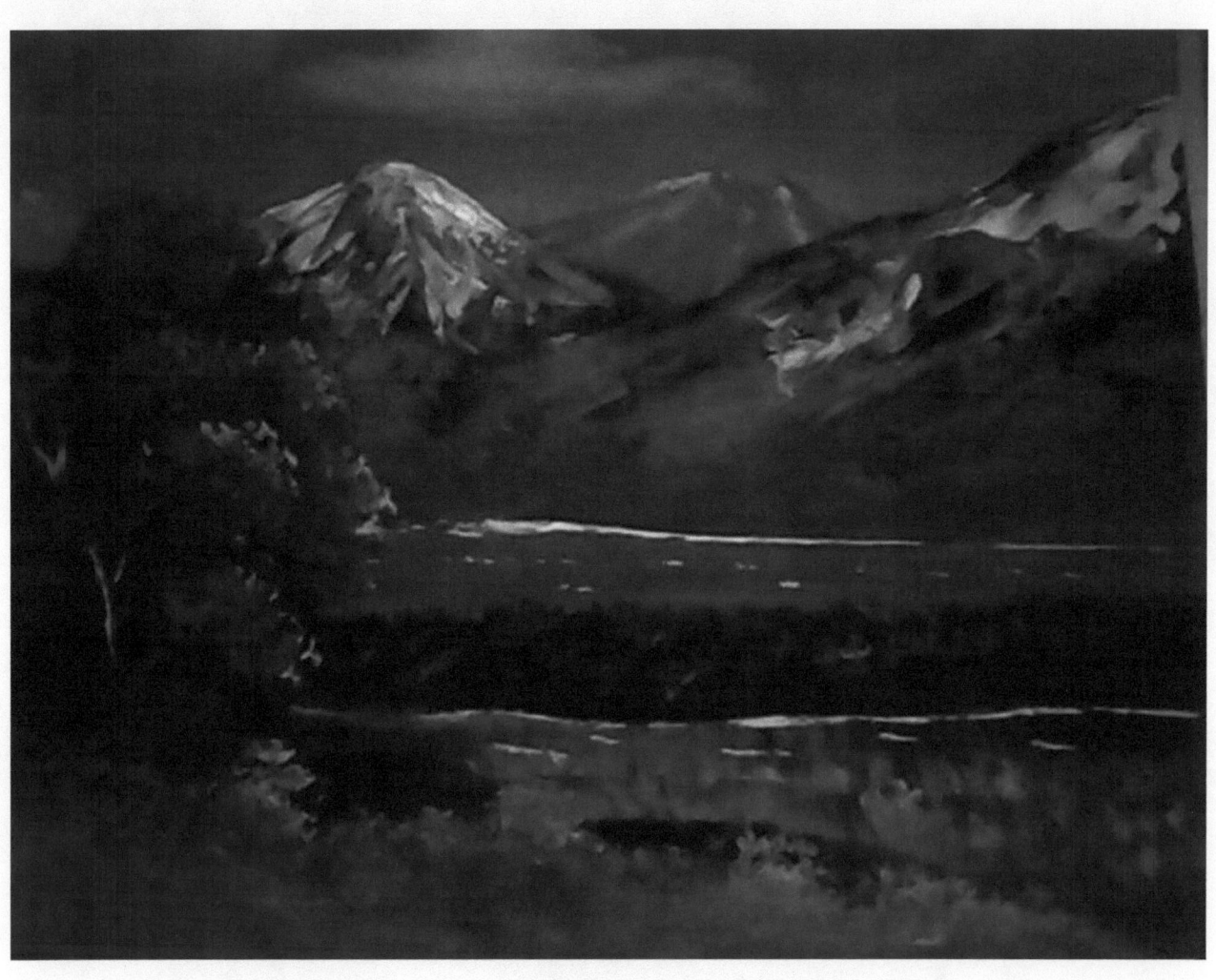

SNOWY RANGE

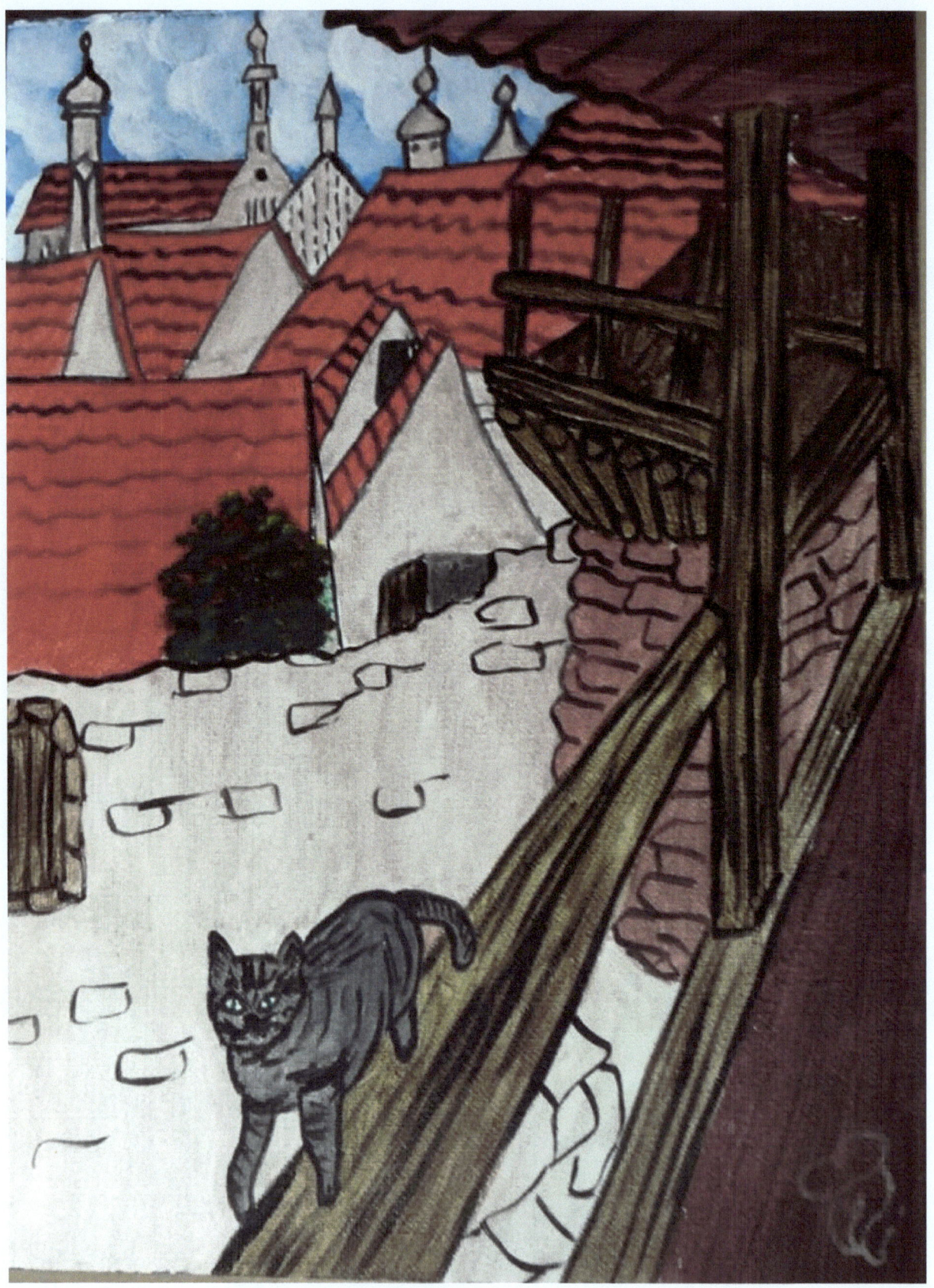

ROOFS

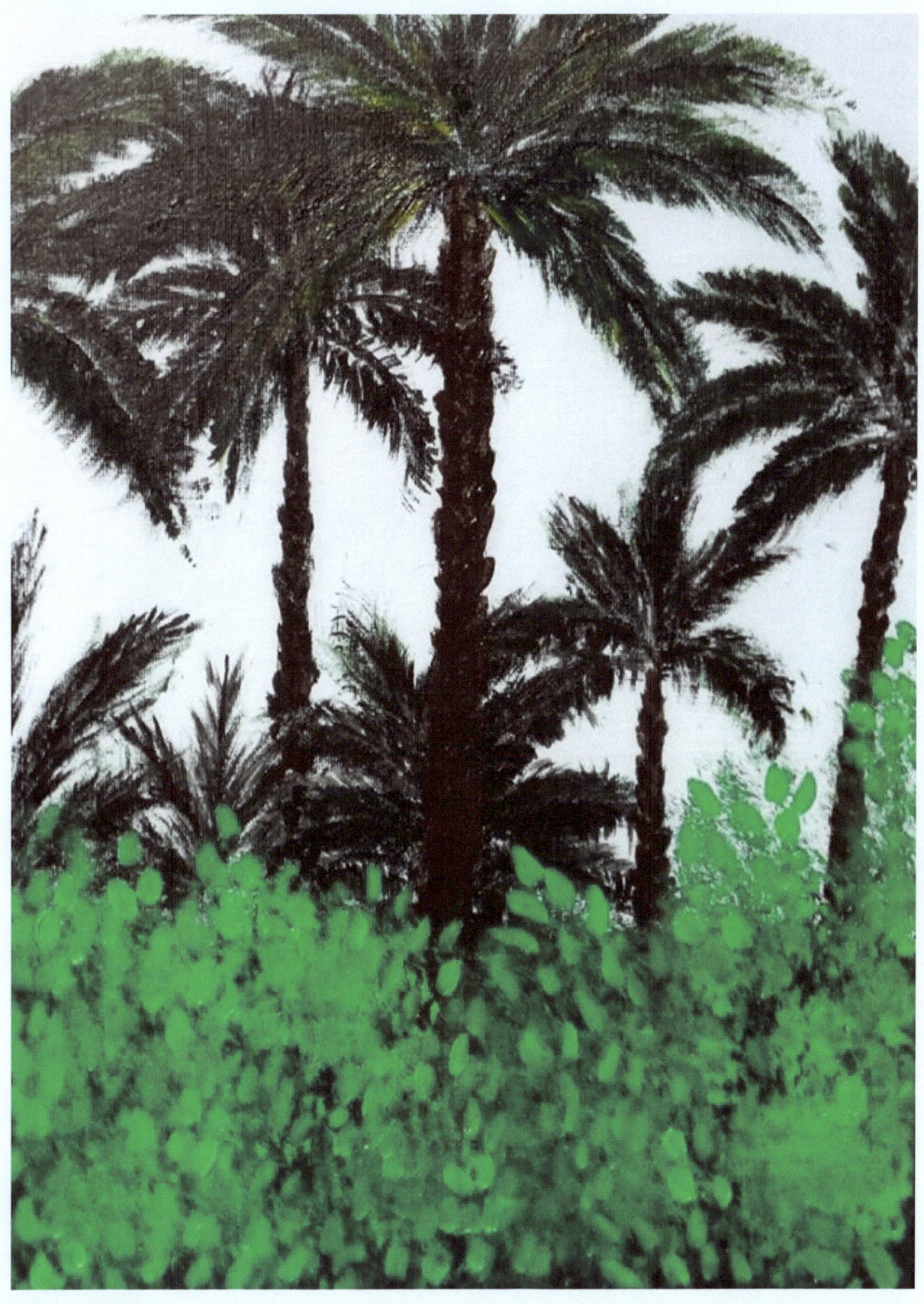

ORCHARD

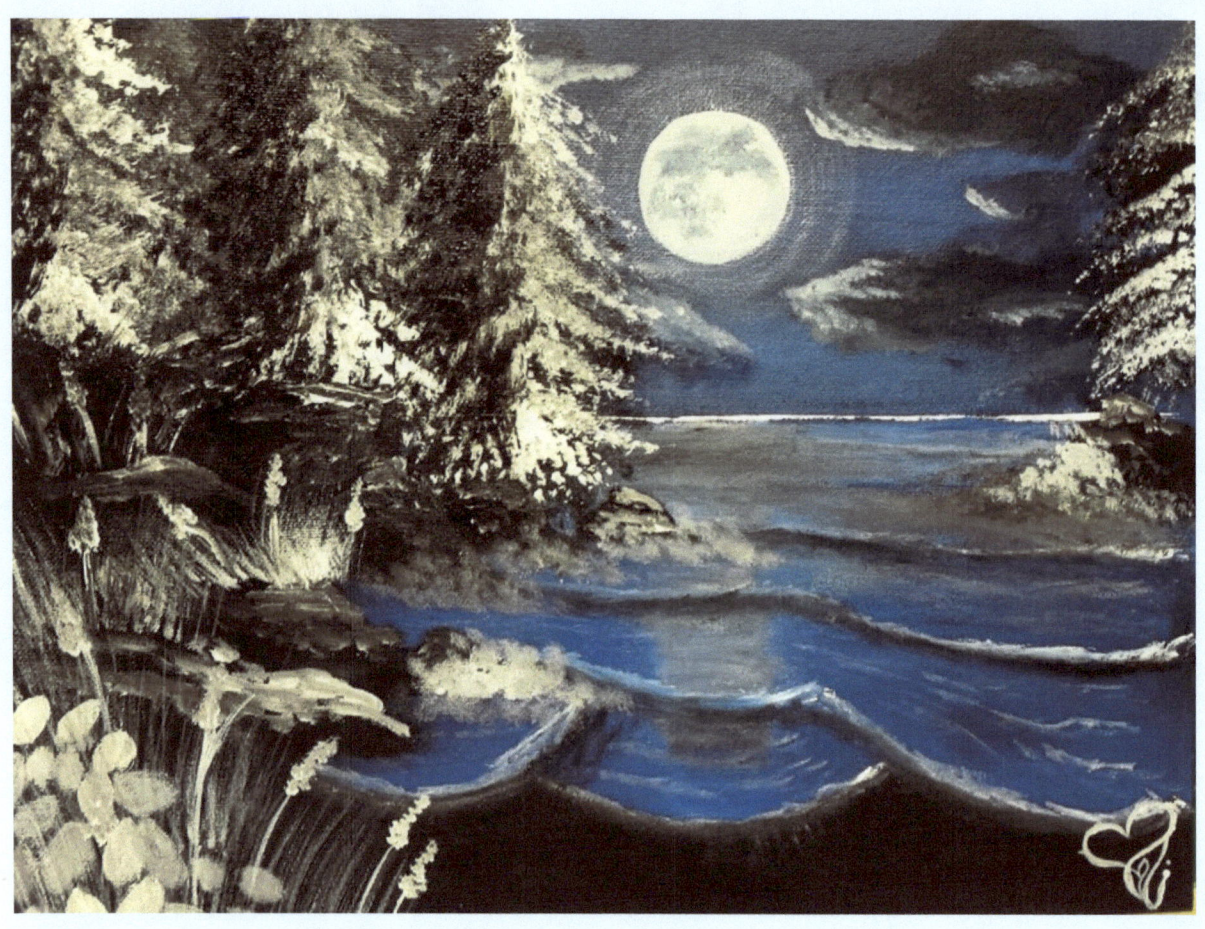

A CALM NIGHT

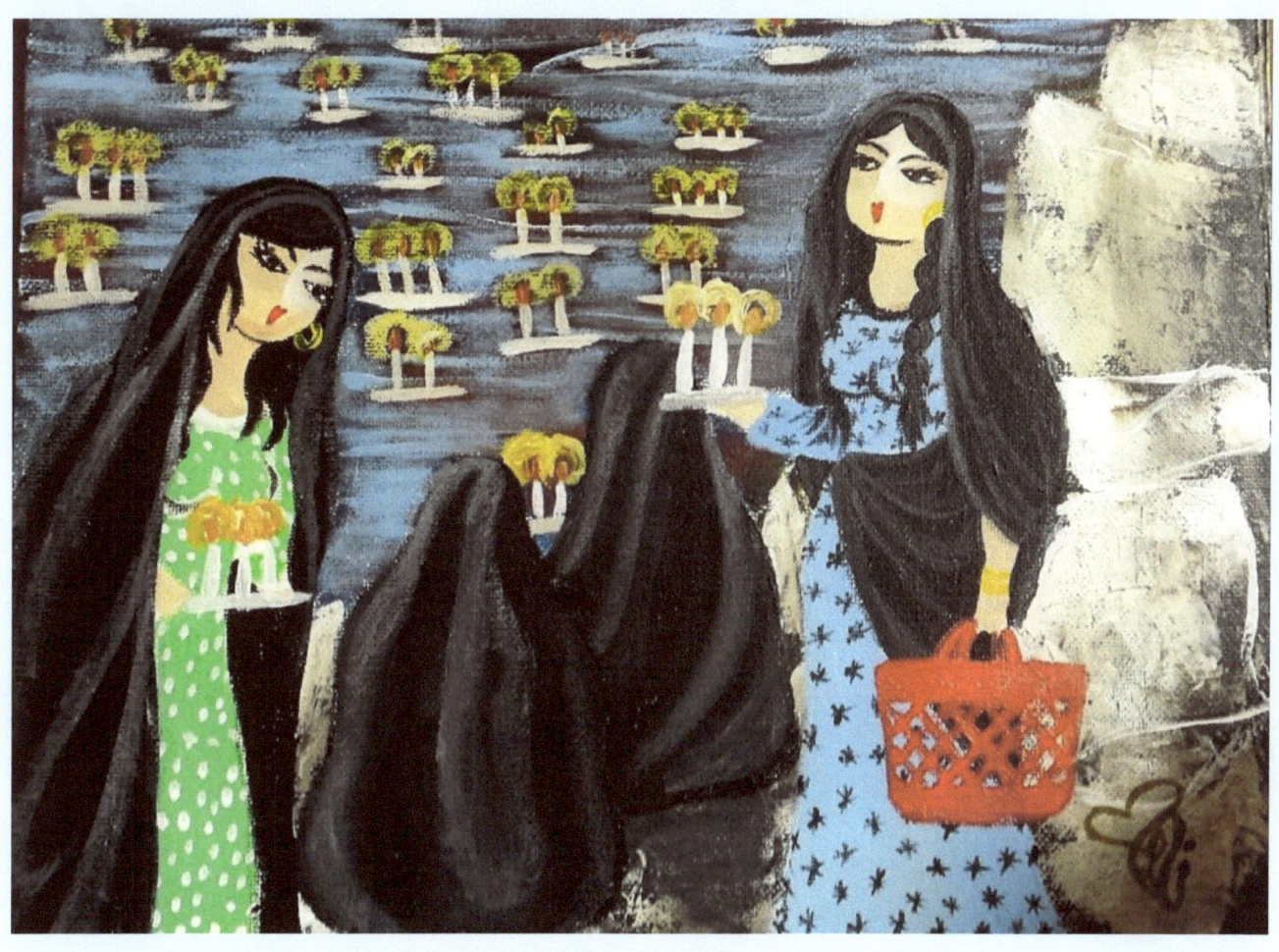

AL-KHIDHIR CANDLES

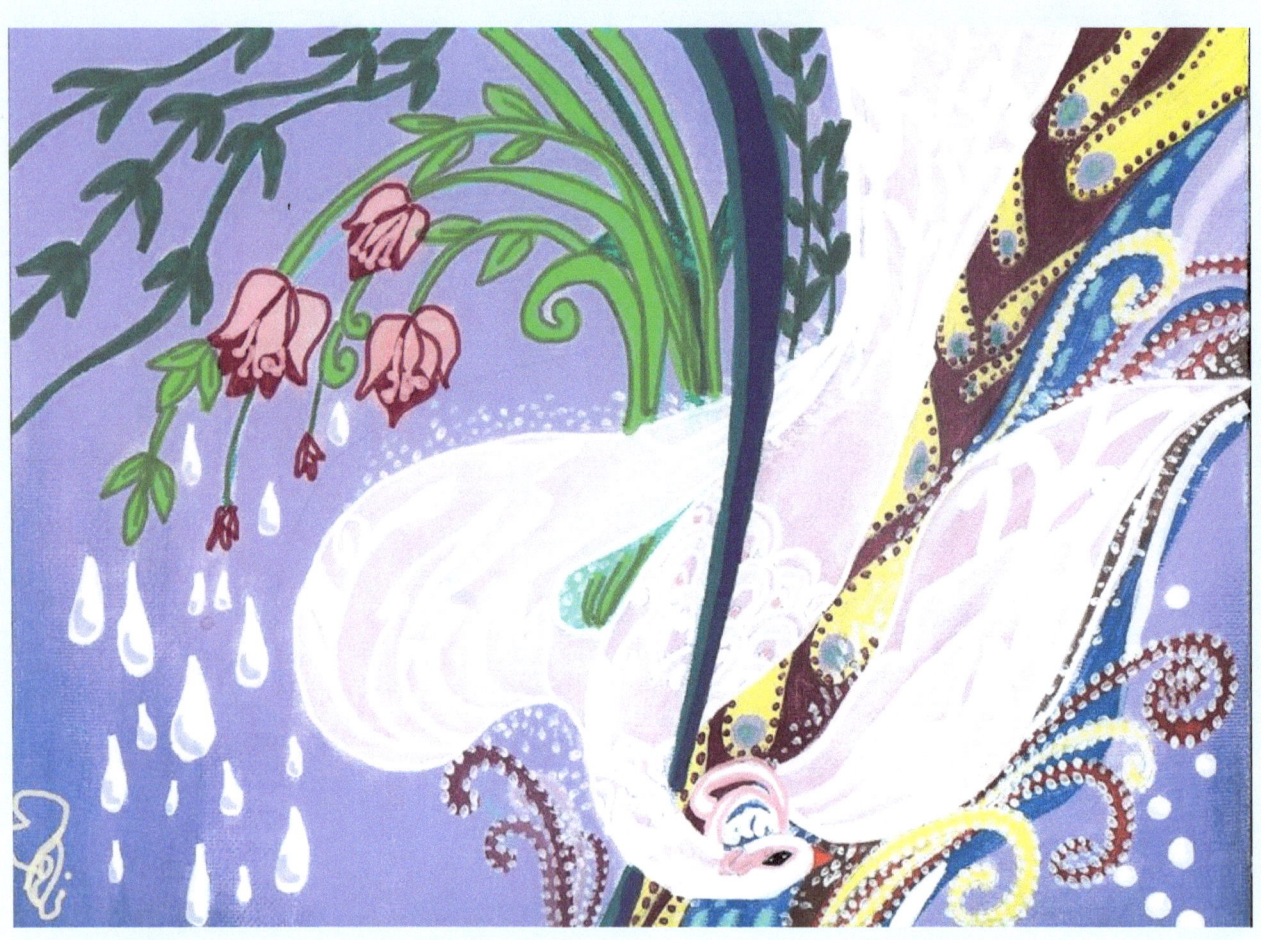

A MAGIC BIRD

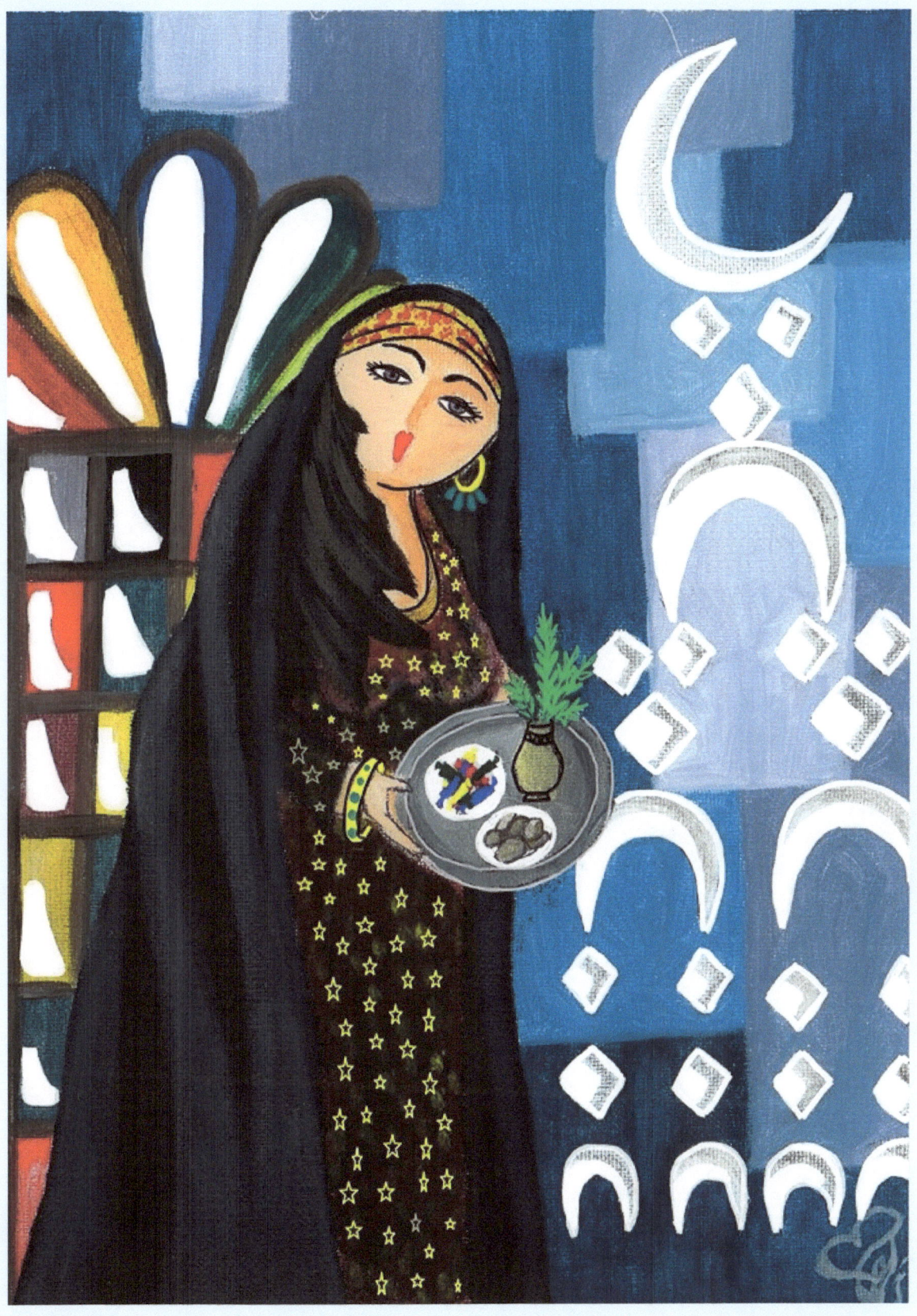

ZAKARIYA

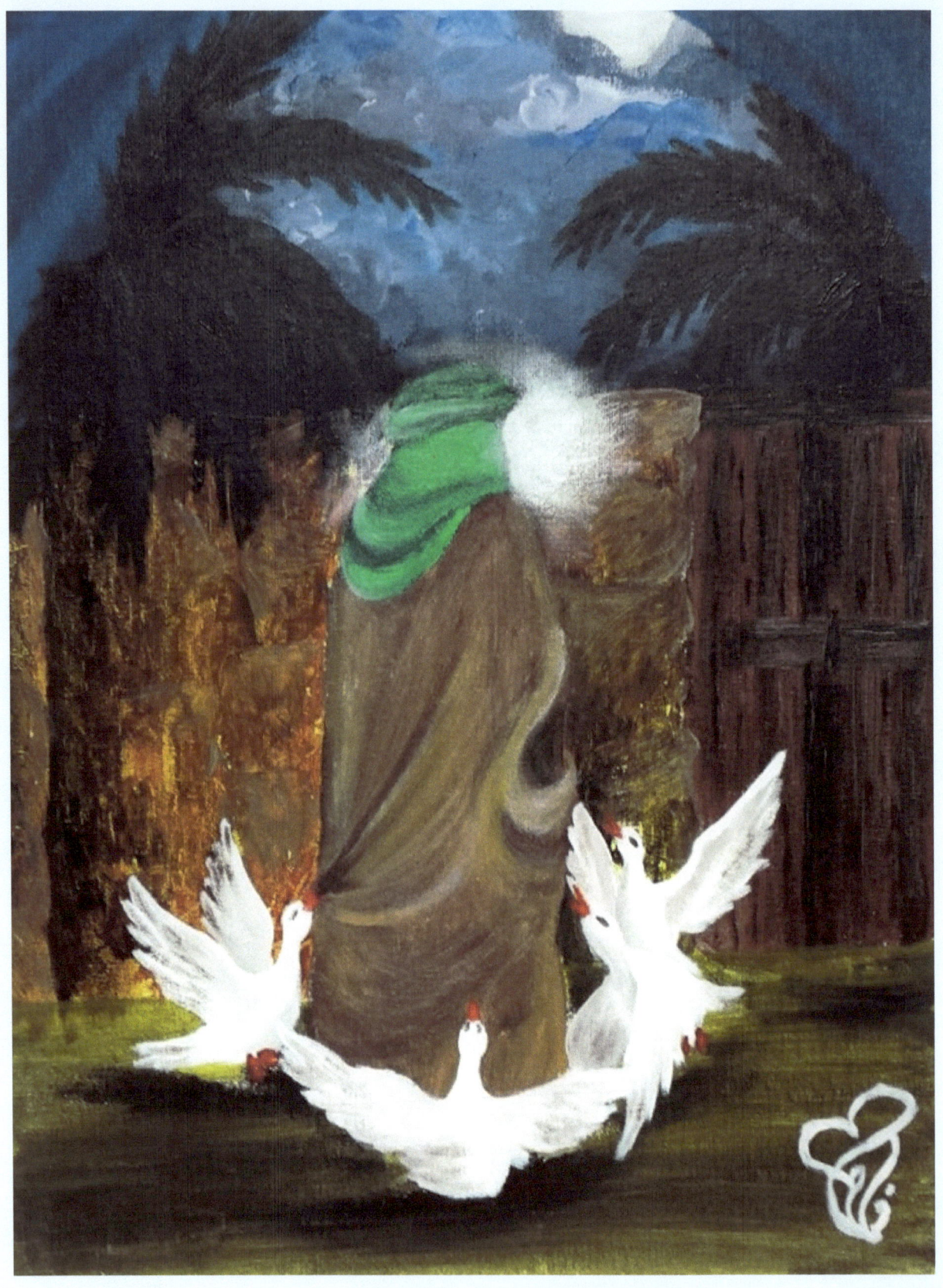

MIHRAB MARTYR

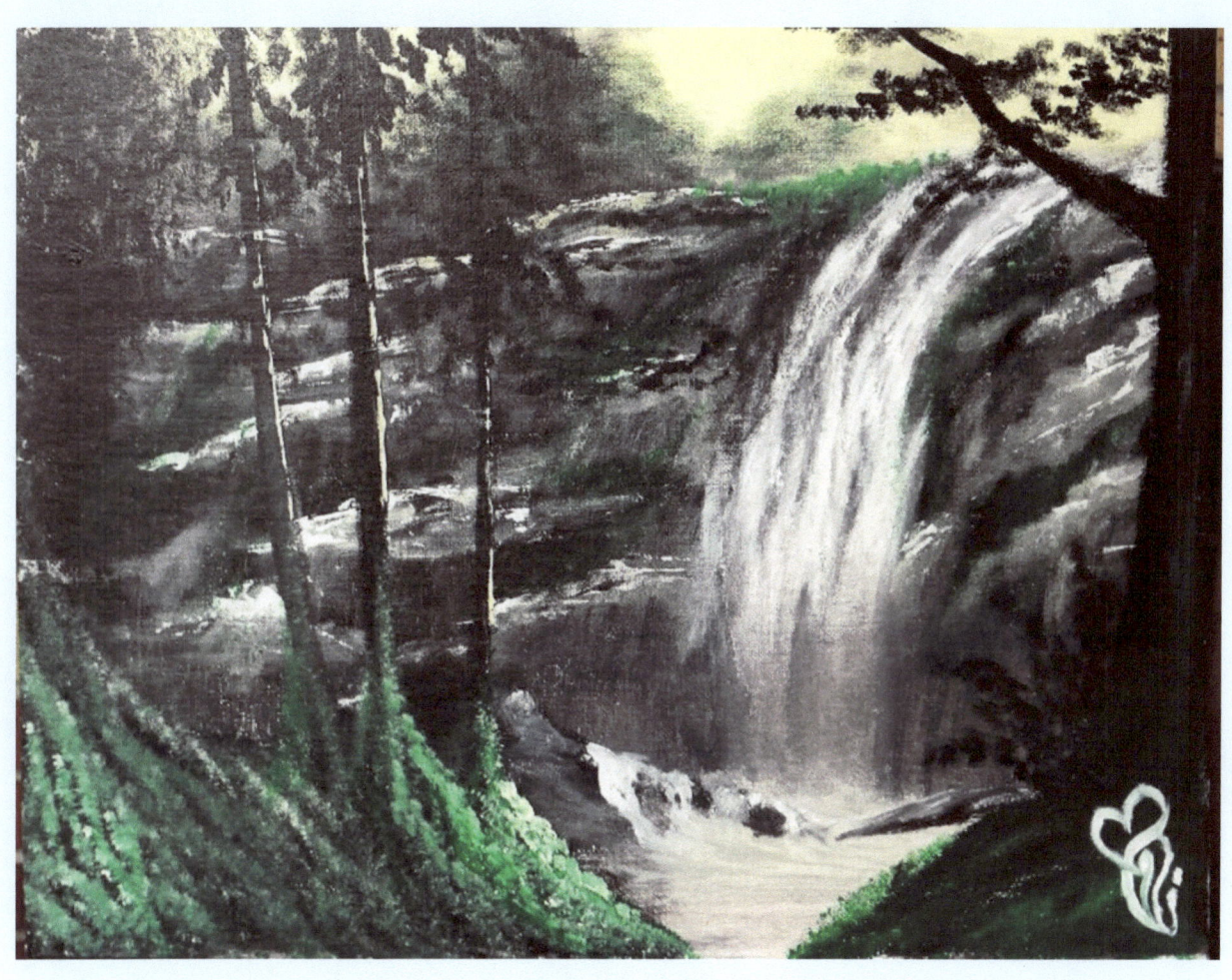

FOLLIAGE

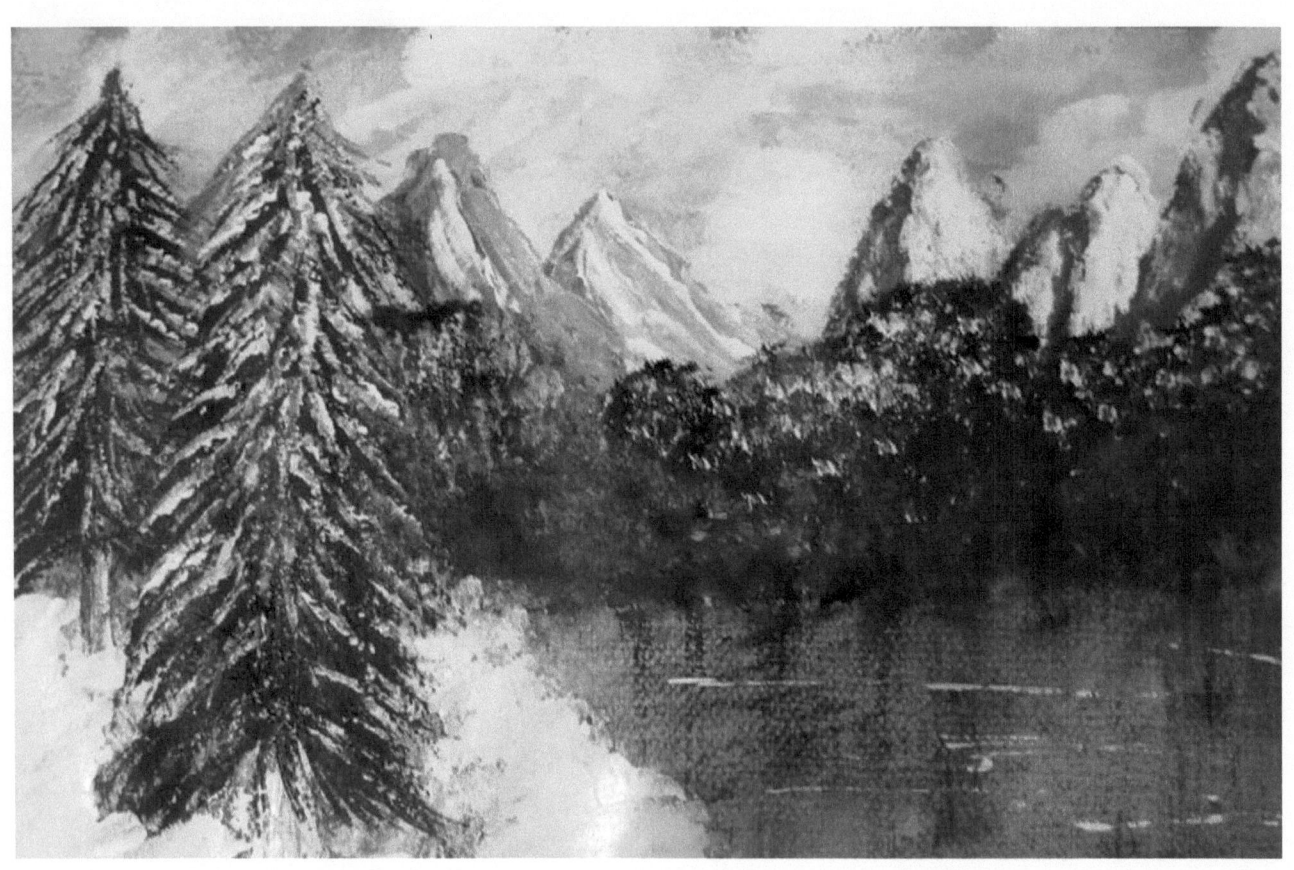

WINTER STORM

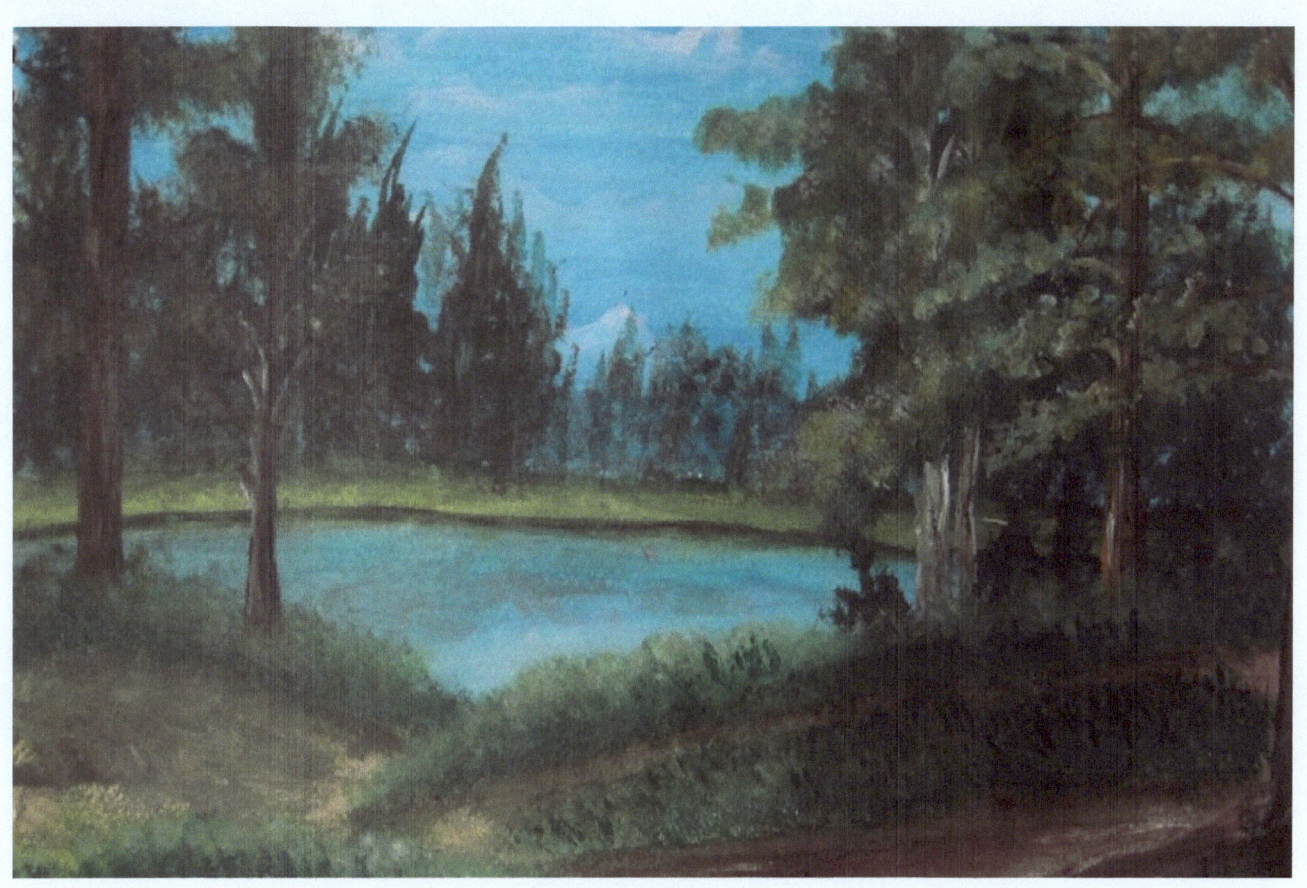

GREENARIES

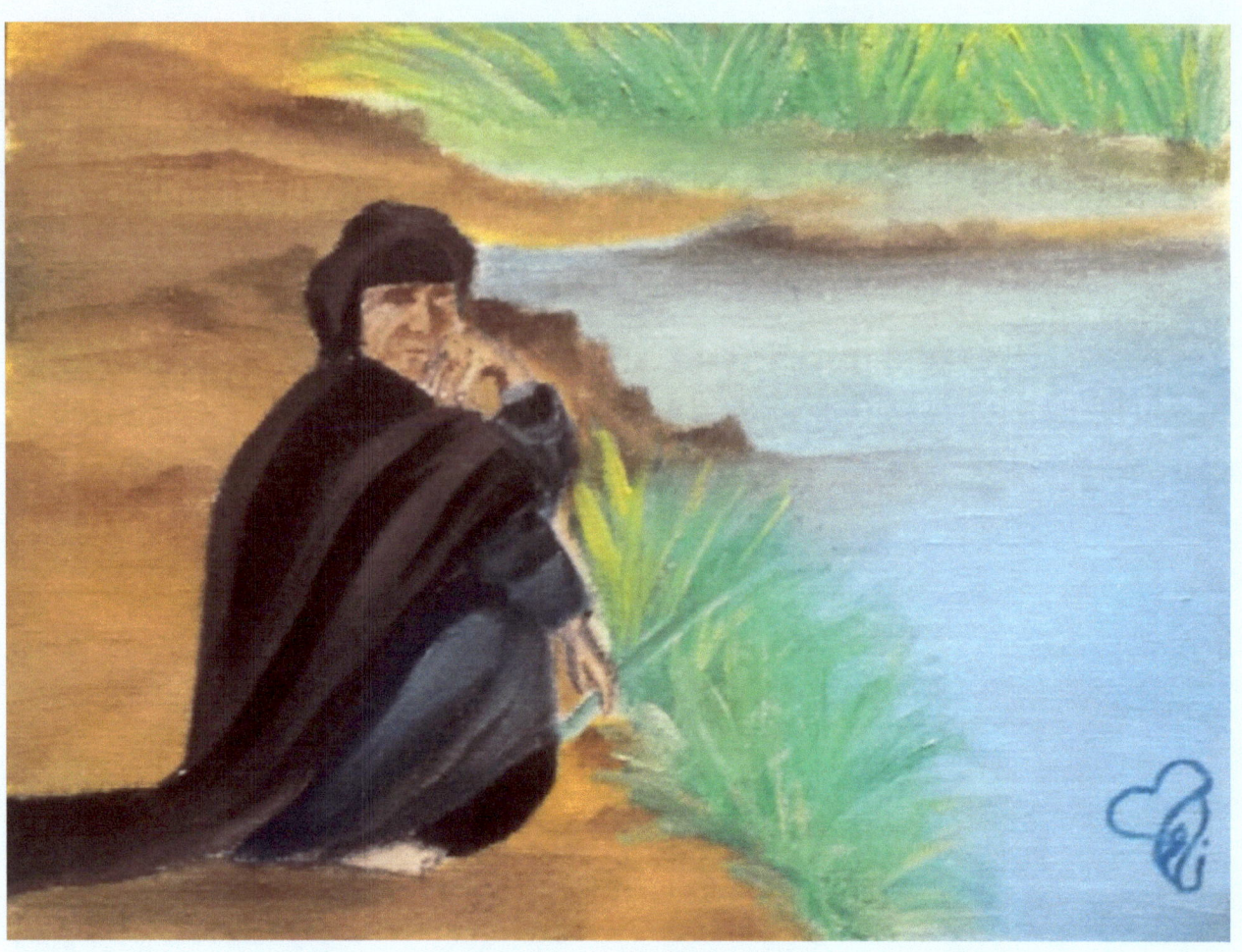

THE ROSE OF THE SOUTH

## ABOUT THE AUTHOR

Fatimah is a PhD candidate at the University of Wyoming. She had her Master's degree in Linguistics from the University of Baghdad in which she taught for four years. She participated in the Fulbright program in 2011 in Bluefield State College in West Virginia. She has one novel, two collections of short stories, and one poetry book published in the United States. She published several research papers in recognized international and U.S. journals. She is working on two novels in English and three other ones in Arabic.

www.ingramcontent.com/pod-product-compliance
Lightning Source LLC
Chambersburg PA
CBHW050356180526
45159CB00005B/2036